THE EGYPTIAN BOOK OF LIFE

THE EGYPTIAN BOOK OF LIFE

Symbolism of Ancient Egyptian Temple and Tomb Art

MELISSA LITTLEFIELD APPLEGATE

Health Communications, Inc.
Deerfield Beach, Florida

www.hci-online.com

Cataloging-in-Publication data is on file with The Library of Congress.

©2000 Health Communications, Inc.
ISBN 1-55874-885-7

Publisher: Health Communications, Inc.
 3201 S.W. 15th Street
 Deerfield Beach, FL 33442-8190

Cover design by Andrea Perrine Brower
Inside book design by Dawn Grove and Andrea Perrine Brower

This book is dedicated to my beloved son,

Scott Douglas Applegate, Captain, U.S. Army.

CONTENTS

PREFACE

Like many cultures, the ancient Egyptians created stories, or myths, to explain their perception of universal principles such as space, time, life and death. These stories both entertained and educated and were passed down from generation to generation like treasured heirlooms. That these myths sometimes seemingly contradicted one another evidently was insignificant to the Egyptians. Perhaps their broad perspective of the nature of reality took into account these disparities or possibly some of the stories became distorted with the passage of time. Unfortunately, we may never really know whether the discrepancies were intentional or not.

What we do know is that the deeper meaning of these "myths" was often deliberately camouflaged in subtle symbolism accessible only to the sincere seeker of wisdom. Within this context, the ancient Egyptians present an orderly and extensive body of knowledge that encompasses a wide range of topics such as art, music, architecture, agriculture, medicine, astronomy, astrology, geometry, physics and more. Intriguingly, all such "myths" reportedly contained three layers of meaning: the first layer was for the general public and was broad in context; the second was oriented for the priesthood and contained privileged esoteric information; and the third was for select

individuals such as the pharaoh and hierophant and contained the deepest and most profound revelations. The knowledge contained within the latter two categories was rarely revealed or discussed outside of the priesthood. Thus, the Mystery Schools were born and flourished, not only in ancient Egypt, but in other locations such as Persia, Greece, Rome, India, China and the Americas.

Various mediums such as painting and sculpture, theater, and handwritten texts were used to portray the story lines of the myths. Although only a few of the texts have been recovered (such as the *Book of Coming Forth by Day*, erroneously known as *The Egyptian Book of the Dead*), much of the art that adorned the ancient Egyptians' tombs and temples is still extant today. The artisans of these great monuments no longer exist; however, the myths themselves live on and speak through the art more than five thousand years later.

In 1998, Peter Vegso, president of Health Communications, Inc., a successful book publisher based in South Florida, set out to develop Reading Etc., a show room of unique, upscale gifts, accessories, books and custom handcrafted stationery. Part of his vision entailed creating an ambiance of magic and mystery, one that honored knowledge, creativity and imagination. An Egyptian motif developed, reflecting a culture steeped in the values Mr. Vegso identified as important in the evolution of this new venture.

In 1999, I began researching ancient images and selecting elements that would accurately represent the Egyptian perspective of cosmology, or the creation of the universe. These elements were then interpreted, hand-carved and painted by artists to create more than fifty friezes that have become an integral part of the Reading Etc. design. (For more

information about Reading Etc., please see the back of this book.) The scenes, which are ordered to convey the ancient Egyptians' views on life and death, may be experienced in their entirety while browsing Reading Etc., and replicas of individual scenes are available to add to your personal art collection. The symbolism of each is described within this book as well as the potential benefit of displaying them. After all, the Egyptians themselves painted and sculpted these scenes in the belief they would create not only beautiful works of art, but serve as tools or talismans to effect happiness and well-being.

As with any piece of art, interpretation is personal to the beholder. One person looks at a painting and sees a certain image whereas another looks and sees something entirely different. Similarly, the comments contained within this book are merely my own viewpoints, a personal interpretation of an ageless, universal story. It is, therefore, important that you use your own imagination and insight while studying these works of art in order to perceive the wisdom contained not only within the first level, but the second and third levels, as well.

It should be noted that a few of the scenes were edited in order to meet specific architectural and esthetic requirements of the showroom. Although removing any element from a scene is unfortunate (as it may alter the original symbolism of the story), there were some instances where we had no alternative but to do so. These elements, however, are merely "first level." If you look beyond with the eyes and ears of *Ma'at* (truth), nothing is lost. *All Is Divinely Ordered and Infinitely One.*

<div align="right">

Melissa Littlefield Applegate
Palm Springs, Florida

</div>

ACKNOWLEDGMENTS

The Egyptian Book of Life is the result of many helping hands, in particular, Peter Vegso, president and publisher of Health Communications, Inc., whose expansive insight, generosity and commitment served as the foundation, inspiration and motivation for the project; Theresa Peluso, executive assistant to the publisher, whose organization and follow-through served as the life force; to Kim Weiss of Health Communications and its Simcha Press imprint, who first approached me and asked me to share my knowledge of Egyptian cosmology with Reading Etc.; to Christine Belleris, Allison Janse, Larissa Hise Henoch, Andrea Brower and Dawn Grove for their indispensable assistance, patience and creativity in editing and designing the book; Norberto Grundland of Manufacturing by Skema for beautifully and accurately interpreting my ideas into artistic form; to Daniel Quiroz and Adriana Rojas of Antes de Cristo for bringing the art to life with their love, patience and humility; to Egyptian Keyholders (Sky, Kitty, Peggy, Marcia, Veronica, Jonnie Ruth, Jo Ann, Cecelia, Kay, Jo Lin and Bil) for their circle of support; to the modern-day Egyptian people for their warm and gracious hospitality; to the Egyptian Department of Antiquities for the preservation and restoration of the ancient Egyptians' art, architecture and artifacts; to

scientist and crystallographer Dr. Marcel Vogel for teaching me the method to access "records written in stone"; Ron and Roberta Carson of Lifestream Associates for the crystalline instruments to do so; sisters Helene Plumstead and Michele Zorb for their emotional support and research assistance; the Egyptian neteroo for their love, patience and endless tutoring; and, most especially, heartfelt love and gratitude to the neter Thoth for his unusual and unexpected appearance in my life so many years ago, which led me full circle to the Egyptian Way of Life!

INTRODUCTION

L ife, death and what follows death fascinated the ancient Egyptians more than any other themes. Whether living or deceased, much effort was undertaken to ensure that each person was protected, nurtured, surrounded by loved ones, entertained, and supplied with the bounty and joy of heaven and earth. *Spend the day merrily! Put ointment and fine oil to your nostrils and lotus flowers on the body of your beloved. . . . Spend the day merrily and weary not therein.*[1] These words inscribed on a wall of an ancient Egyptian tomb express the common Egyptian sentiment to enjoy life to its fullest even in the midst of tragedy. They lived simply and entertained themselves with singing, dancing, hunting, boating, poetry, board games, banquets, beer and wine. In every household, elaborate rituals and spiritual disciplines were employed to ensure that the **ka** (one's personality or spirit) did not become mired in inferior realms of behavior that might detract from personal happiness and well-being.

[1] *Ancient Egypt: Discovering Its Pleasures* (Washington, D.C.: National Geographic Society, 1978), 102.

To this end, it's evident that the ancient Egyptians did, indeed, enjoy a high quality of life. Herodotus, the Greek historian of 500 B.C. who became known as "The Father of History," stated, "Of all the nations of the world, the Egyptians are the happiest, healthiest and most religious."[2]

At first glance, one might make the assumption that the Egyptians were polytheistic (or believed in more than one god). Hundreds of tombs and temples are dedicated to a pantheon of "gods" and "goddesses" such as **Ra, Osiris, Isis, Hathor, Horus** and **Thoth**. In fact, nothing could be further from the truth. The Egyptians perceived the ultimate Divinity as having both manifest and nonmanifest components. That which was nonmanifest was formless, nameless and beyond mortal description. It was out of this self-aware *formlessness* that all *form* arose—the sky, the stars, the earth, water, humans, animals, vegetation, and so on and so forth. Furthermore, according to ancient Egyptian cosmology, form itself has certain systematic and predictable archetypal principles called **neteroo**. Unfortunately, the word neteroo was mistranslated in modern times as "gods and goddesses," resulting in a great deal of misunderstanding regarding the beliefs and practices of the ancient Egyptians. For example, the **neter** Ra became personified as an Egyptian "sun god" rather than solar force, an element of nature.

A UNIFIED ONE

Today, through modern physics, we know that the world is held together by various elements or archetypal principles such as gravity,

[2] Moustafa Gadalla, *Egyptian Cosmology: The Absolute Harmony* (Erie, Pa.: Bastet Publishing, 1997).

electromagnetism, a strong force and a weak force. Unified Field Theory attempts to unite these forces as one. The ancient Egyptians' concept of neteroo was similar to our own in that they, too, recognized primordial forces that govern all matter and can be unified as One. Parable and myth helped simplify these complex teachings so that the masses could comprehend the universal principles that govern all life and pass the teachings onto their children and childrens' children.

Curiously, Egyptian creation myths parallel findings only recently discovered by scientists of today. About 15 billion years ago, the universe was tightly packed together in a dense neutron soup. The Egyptians called this soup the "primordial waters of **Nun**" and described it as an infinitely dark, chaotic, watery abyss in which there was no "up" nor "down" nor direction of any kind.

According to the mythology, **Atum**, a neter of primordial light, emerged from the dark sea of Nun through an act of self-awareness and the first ray of Atum's light fell upon the **primordial mound.** The primordial mound is described as "the place where the sun first rose," a heap of sand or rock that emerged from the primordial waters and was composed of Atum's children, four ordered pairs of neteroo, both male and female. Although the exact location of the original mound was never determined, pyramidal-shaped shrines symbolic of the sacred mound and **obelisks** representing the first ray of light were erected and venerated in various locations throughout ancient Egypt.

The four pairs of neteroo (Atum's "children") were named as follows:

NETER (masculine)			NETERT (feminine)		
1. **Shu**	=	Wind	+ **Tefnut**	=	Moisture
2. **Geb**	=	Earth	+ **Nut**	=	Sky
3. **Osiris**	=	Death	+ **Isis**	=	Birth
4. **Set**	=	Dispersion	+ **Nephthys**	=	Cohesion

These eight forces plus the ninth force of Atum (who was known as "the all" and "he who came into being of himself") made up the **Divine Ennead**. The Divine Ennead was considered to be one all-inclusive force as well as nine separate forces. Each pair of forces had its specific function. For example, the paired neteroo of **Set** and **Nephthys** express principles of magnetism. All that could be seen, heard, touched, tasted or smelled was thought to be composed of these fundamental forces. In fact, *everything* in the Universe was considered a part of the Divine Ennead emanating as a manifestation of Atum. (Not coincidentally, the "atom" is recognized today as the building block of all matter.)

Having said this, I somewhat hesitantly elect to use the terms "gods" and "goddesses" interchangeably with neter, netert and neteroo throughout the course of this book. The introduction of "deified" beings such as Osiris and Isis over the course of time may demonstrate a cultural need to personalize the impersonal in order to make it intellectually more accessible. As an example, in our own culture the

archetype "Santa Claus" is a beneficent being who generously distributes gifts to good boys and girls and symbolizes the very real, albeit impersonal forces (neteroo), of love and karma. Whether Osiris, Isis or Santa Claus actually existed historically is far less significant than the qualities they represent. And frankly, the myth of Santa might be far less memorable if expressed in generic terms of "good deeds result in good rewards" rather than in the colorful imagery of jolly old Saint Nick sailing the night sky in his miniature sleigh led by eight tiny reindeer.

Perhaps it is for this very reason that Egyptian myth presents dramatic imagery that defies logic (such as "gods" and "goddesses" with human bodies and animal heads) and contradicts itself from story to story. And yet, as the larger picture unfolds, these contradictions become less defined and take on the shape of an amazing tapestry that reflects the beauty and mystery of life itself!

So with no further ado, let us review the legacy left by the ancient Egyptians for future generations to reflect upon, known simply as *The Egyptian Book of Life.*

1

BEFORE THE BEGINNING

How did life begin? What was *before* the beginning? Is there life *after* death? In the larger universal scheme of things, what role do we humans play? These perplexing questions were carefully pondered by the ancient Egyptians thousands of years ago, and their answers painstakingly recorded in art, architecture, **papyrus** scrolls and other mediums. Perhaps the most accessible of these mediums is the art on the walls of the ancient Egyptians' temples and tombs as it is prolific and largely intact despite the passage of time. Monuments rivaling some of the most spectacular in the world reveal subtle clues camouflaged in the language of symbolism that respond to these age-old, universal inquiries.

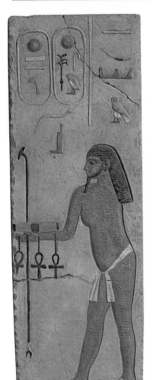

Fig. 1-A, Atum in Watery State

Placing "Atum in Watery State" and "Atum in Dualistic Form" in your home or office enhances creativity and the manifestation of intentions and goals. It brings unity to various factions of self and the inhabitants of the dwelling in which it is hung. It may also help reveal one's *true nature and spiritual purpose*. If there are no lakes, rivers or other bodies of water nearby, or if the element of water is scarce (i.e., no fish tanks, lily or fish ponds, water fountains, etc.), it can establish more water energy and bring balance to the basic elements of your structure. It may also increase fertility.

Specifically, what does Egyptian art tell us about our origin? It tells us that the Egyptians had more than one theory as to how it all began. Just as we, today, debate whether we "evolved" or were "created," the Egyptians proposed various themes of origination. Scene 1-A is one such theme but it's certainly not the final word on the subject; however, it's a good place to begin. It reveals what the Egyptians believed was *before the beginning* as well as the *beginning itself*. In this scene, the **neter Atum** is depicted in his "watery" state (or in other words as an aspect of **Nun**—the sea of neutron soup), his body entirely composed of waves. As the neter who "came into being of himself," he displays both male and female attributes for purposes of autogenesis. This is accentuated by his masculine beard and pendent feminine breast. He holds the **uas scepter** in his right hand, denoting his status as **neteroo** (only neteroo carry this particular type of scepter), as well as an offering tray upon which hang three **ankhs**, the symbol of life.

To the casual observer, it may seem peculiar that Atum's left arm is conspicuously missing. As neteroo represent the perfection of nature, a birth defect or casualty would indeed be highly unusual. Whenever an oddity such as this appears in Egyptian art, you can rest assured it's not by chance circumstance or mistake. To the contrary, a significant point is being raised. In this instance, the left arm is considered an instrument for "receiving" and the right arm an instrument for "giving." Therefore, with right arm extended and left arm noticeably absent, the point being emphasized is that Atum is a *giver of life* as evidenced by the three ankhs (symbols of life) on the offering tray.

But why three ankhs? Why not one, or four or five?

In order to answer this question, some knowledge of sacred geometry is required. As you probably know, all matter in the universe can be reduced to mathematics or numbers. Although many of us have difficulty understanding mathematical concepts, sacred geometry was one of the most valued arts in the Egyptian Mystery Schools. Therefore, having a basic comprehension of it is intrinsic to understanding Egyptian cosmology. Although these concepts may be difficult to grasp at first, once you do, the rest is easy. And if you don't, don't be discouraged. Just skip over it and come back later. Rereading it has the potential to affect learning in subtle ways. Eventually, you'll get it!

As previously stated, all matter reduces to numbers. For example, computer language is based solely on the numbers 0 and 1. We use letters and numbers today to express ideas and concepts in written form. Remember Einstein and his theory of relativity, $E=mc^2$? The ancient Egyptians utilized more than seven hundred geometric symbols and

pictographs called **hieroglyphs** to express conceptual thought. The circle, square, ovoid, triangle, cross and straight line all had specific meaning and function to the ancient Egyptians. Some of these basic concepts have carried forth into our own language and numeric systems. For example, the ovoid was equated with an egg, a symbol representing fertility, creation and the beginning. In geometry today, the ovoid is the numeric equivalent of zero—or nothing—the void. Similarly, the ancient Egyptians viewed Nun (pronounced "none," a word we equate with zero) as the abyss of nothingness. According to the Egyptians, it was out of this nothingness that all form (Atum) was born.

In the world of physics, an atom is so small that when we look at it with the physical eye, we see nothing. It is energy, a force that appears as a small circle or zero when magnified. If we draw a small point (like the dot above an "i" for example) and hold a pencil upon this dot and move the lead in a linear fashion away from the dot forming a straight line, two dots are formed connected by a singular straight line.

In a similar fashion, formlessness (symbolically represented by the one small point your pencil is placed upon) moves into form through motion (moving the lead in a linear fashion) and becomes two points or dualistic (see the diagram above). This is known as **yin** and **yang**.

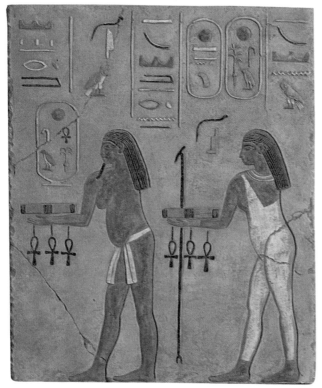

All physical matter is governed by properties of yin and yang (such as birth/death, male/female, day/night, good/evil, cold/hot, wet/dry, etc.). We have two eyes, two ears, two nostrils, two arms, two legs, left brain + right brain, etc. This is due to the law of duality. However, in becoming physical (or dualistic), the formless remains inherently contained within the form. Thereby, 1 + 2 = 3, or a trinity. It is this concept of sacred geometry that is expressed by the three ankhs of Atum representing the union of spirit (formlessness) with matter (form).

Nearly all traditions make reference to this triune aspect of being. For example, in the Christian religion, Divine manifestation is represented as: God the Father, God the Son and God the Holy Ghost; in the Hindu tradition: Brahma, Shiva and Vishnu; and within the Egyptian pantheon triads such as **Osiris, Isis** and **Horus** serve to express this fundamental concept of "becoming."

Fig. 1-B, Atum in Dualistic Form

In **Fig. 1-B,** Atum moves from formlessness into form, thereby completing the Divine Triad. Upon assuming material form, his body becomes flesh and bone and is no longer watery. Furthermore, because form is dualistic in nature, he is simultaneously represented as a female wearing only a jeweled collar with uas scepter and three ankhs in her right hand and as a male with beard, loincloth, uas scepter and the three ankhs in his right hand. Altogether there are nine ankhs, representing the **Divine Ennead.**

The ankh itself also serves to express sacred geometry. It is comprised of an ovoid perched on top of a "T." On a macrocosmic level, the ovoid denotes the formlessness out of which all life is born. The "T" has three points symbolizing the triune manifestation of matter (time, space and consciousness). On a microcosmic level, the ovoid represents the female genitalia and the "T" the male genitalia. The union of the ovoid and the "T," either macrocosmically or microcosmically, results in life, and to this end, the ankh is depicted in nearly every scene of Egyptian art and text as it is considered the most sacred of all symbols.

2

THE GARDEN OF LIFE

Cultures from all around the globe describe a garden of unparalleled beauty and pure innocence inhabited by the first man and woman at the beginning of time. Whether referred to as the Garden of Eden, Shangri-la, Shambhala, Atlantis, Lemuria, the Elysian Fields, Ialu, or the Tree of Life, the *garden* is a metaphor for the mystic marriage between heaven and earth (formlessness and form). It is not only a geographical place—real or imagined—but a state of consciousness in which the lower elements of self (such as instinct) are united with the higher elements of the Divine (love and wisdom). As conflict between these elements is unified, one is able to live harmoniously with nature and be supported by it, rather than at odds with it or at its mercy.

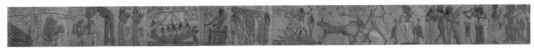

Egyptian temple and tomb art depicts various scenes of the sacred garden such as **Fig. 2** in which a couple accepts food offered from the Tree of Life. Interestingly, elements of Egyptian creation myths parallel those of other cultures and religions. In the Bible, for instance, Adam

Fig. 2, Sky Goddess Nut and the Tree of Life

Placing "Sky Goddess Nut and the Tree of Life" in your home or office creates an atmosphere of growth, nurturing, vitality and abundance. It is regenerative and balancing for those who have a tendency to spend long hours indoors or are introverted. It is also soothing for those with excitable temperaments as it integrates all five of the natural elements: fire, water, earth, air and ether. (This panel is a composite of two separate scenes reflecting similar themes and has been altered slightly in order to avoid duplication.)

and Eve lived happily in the Garden of Eden until a serpent tempted Eve to eat an apple from the Tree of Knowledge. Coincidentally, the first being of the Egyptian pantheon is named **Atum**, phonetically

similar to Adam of the Judeo-Christian tradition. The Egyptian version differs from the Christian in that the Egyptians believed the Tree to be totally life-supporting and there was no snake involved. The Egyptians believed snakes had the potential to be good *or* evil. Some snakes

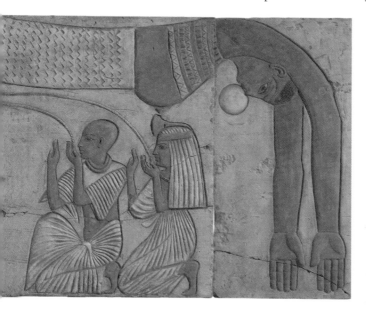

were revered as protective **neteroo** and others feared (such as the serpent **Apep** who devoured the sun on a daily basis). Talismans and magical texts were created as protection against the perils of the latter.

The Egyptians saw the Tree as a *body of life* rather than a *body of knowledge*. They believed true wisdom was contained within the heart, as the heart sustains life. At the time of death, the brain was considered so irrelevant that it was removed from the corpse and totally discarded, whereas the lungs, liver, stomach and intestines were preserved in **canopic jars**. The heart was the only organ to actually remain in the mummy. It was considered vital to the well-being of the soul *even after death* and was left in the chest cavity protected by special amulets and gemstones placed between strips of linen wrapped around the mummified body. That the Egyptians went to such lengths to preserve the heart within the physical body after death emphasizes their

high regard for love over intellect. Certainly they were aware of the suffering that results when heart and mind are not unified. Possibly the biblical representation of the snake and the Tree of Life offers a similar lesson. A state of grace cannot be achieved except through the union of duality: *heaven and earth* on a macrocosmic level, and *love and intellect* on a microcosmic level. Without this marriage, one is metaphorically "cast out" of the sacred garden. The Egyptians perceived the sacred garden as both a physical habitation while living and a heavenly abode once deceased. They acknowledged this principle of unification not only spiritually, but politically as well. The country itself was divided into two lands: "upper" and "lower" Egypt with a specific crown for each. The double crown, an amalgamation of the two crowns, was worn by both neteroo and the **pharaoh** alike as a symbol of being unified.

Various scenes reflecting elements of nature such as the sky, the earth, water, air, men and women, children, birds, cattle, fish, trees, flowers, etc., are depicted in the panels of art, all representative of the miraculous tapestry known as the Garden of Life.

In **Fig. 2**, the **netert Nut** (pronounced "Nu-it") is depicted as a woman with an elongated body that spans the horizon symbolizing the sky arched over her husband **Geb**, the **neter** earth. In this scene, she's shown swallowing the evening sun and giving birth to the morning sun. She is supported and held up by the invisible **Shu,** the neter of air, allowing only her fingertips and toes to longingly touch her husband. The beautiful wavy design on her dress symbolizes the netert **Tefnut,** wife of Shu, or moisture.

The rays emanating from the sun at Nut's belly are shaped like flower blossoms reflecting the generative principle of Nut. This is further emphasized in the cow-faced portrait of the netert **Hathor** in the midst of the sun's rays, known for her life-enhancing and nurturing disposition. Just as a newborn child is nurtured by mother's milk, or the milk of a cow, the earth is nurtured by the cosmic elements of Nut. The rays of the morning sun shine upon the Tree of Life, its outstretched armlike branches offering a tray of food and water to a couple kneeling with reverent gratitude. Two **ba** birds, representing the souls of the couple, drink from a **lotus** pond beneath the Tree of Life.

The sacred Garden denotes a state of grace, a time before—or reconciliation of—the "great fall." In the sacred Garden, we are physically and spiritually nourished, naturally clothed in innocence, and at total peace with our environment. **Fig. 3** symbolizes this perfect state of innocence. In it, four maidens each carry a vessel of water and four vessels of water have been placed on top of stands. The women are dressed in sheer white cloth revealing the natural beauty of their bodies. The color white has long been associated with purity, and water, too, is seen as a symbol of purity as it's an agent for cleansing. The vessel in which the water is contained is a metaphor for the physical body and the water contained within it a symbol of the soul. The resting vessels and carried (or moving) vessels also imply inert and active principles.

Sacred geometry is once again reflected in this particular scene by the repetition of the number four. In sacred geometry, four is the number associated with the earth and the square is its symbol. Not coincidentally, we make reference to "the four corners of the Earth,"

which is ironic since we know the Earth is not square but egg-shaped. In addition, the Earth has four directions (east, west, north and south) and is comprised of four seasons (winter, spring, summer and fall). It's for this reason that the number four represents earthly matters in sacred geometry and is emphasized in this particular scene. Metaphysically speaking, when the Divine assumes human form and incarnates on earth, it is geometrically expressed as follows on the next page.

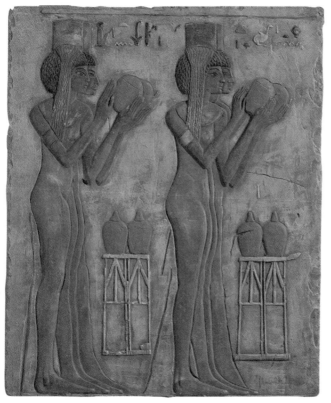

Fig. 3, Maidens Carrying Water Vessels

Placing "Maidens Carrying Water Vessels" in your home or office creates an atmosphere of simplicity and naturalness that enhances harmony, emotional stability, meditative insight and recognition of one's own beauty. It may also be helpful for evoking "sisterly love" and purifying body and mind of negative thoughts, habits and dependencies. If there are no lakes, rivers, or other bodies of water nearby, or if the element of water is scarce (i.e., no fish tanks, lily or fish ponds, water fountains, etc.), it can establish more water energy and bring balance to the basic elements of your structure.

1	Divine	Love	Formlessness	Heaven
±2	Human: (Male/Female)	Wisdom (Mind/Heart)	Form	
=3	Trinity			Mystic Marriage
±1	Space	Movement	Formlessness	
=4	Matter	Actualization	Form	Earth

Once a soul incarnates on Earth, there is a progression of growth and awareness, a forward momentum and expansion of consciousness. We learn how to talk, walk and use our five senses to move through and comprehend life experiences. The ancient Egyptians often portrayed boats in their art and written texts as vehicles to transport the nonphysical aspect of that being. On one level, **Fig. 4** depicts six men navigating a sailboat—an ordinary recreational outing shared by friends. On a deeper level, however, it symbolizes the soul as it evolves and moves through various states of consciousness. For example, the Egyptians believed that at the time of death a "solar barge" transported the deceased into the heavens. This barge sailed upon a river of stars called the **duat** whose description is curiously similar to the Milky Way. They believed the Nile River to be a mirror representation of the duat. They also believed that a barge transported the sun across the sky by day and into the duat at night and this accounted for its movement from the eastern to western horizons on a daily basis.

As human beings, we progress through cycles of maturation, i.e.,

child, teenager and adult. The Egyptians believed that at the height of spiritual maturation, occurring before or after death, each person

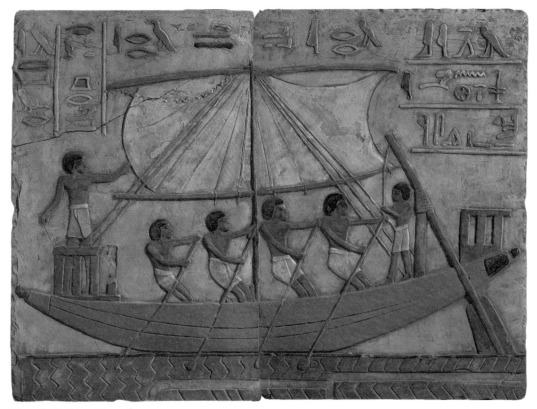

Fig. 4, Sailing Vessel

Placing "Sailing Vessel" in your home or office creates an environment of gentle movement and forward momentum. It invokes enjoyment, self-discipline, good sportsmanship and applied effort to any project, and it may be useful in moving beyond intransitive situations in which one feels "stuck." It enhances camaraderie and "brotherly love," and it amplifies the natural elements of air and water.

transforms into a shining star (or the "sun god" **Ra**). The sun was also recognized to progress through various cycles. For example, the noon

sun is unlike the morning or evening sun. It is hotter and hangs higher in the sky. Specific myths were woven around each of these sun cycles to better define its particular nature.

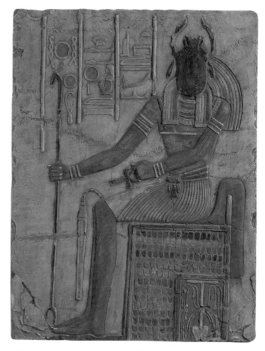

Fig. 5, Scarab-Headed Khepri

One such myth has to do with the neter **Khepri,** the morning sun. Khepri was generally portrayed with a male body and a **scarab** beetle's head. His name means "he who comes into existence" and "scarab."[1] In **Fig. 5,** he's shown seated on a throne with **ankh,** the symbol of life, in his left hand, and **uas scepter** in his right hand, denoting that he is neteroo.

Scarab beetles were quite common in Egypt. When studied closely, it was observed that the scarab pushes a ball of dung in front of itself and then buries it in the earth. Once in the ground, the ball of dung metamorphoses from larvae to pupa, and a scarab emerges and is born anew. The Egyptians observed that the scarab rolling the dung ball mimicked the

Placing "Scarab-Headed Khepri" in your home or office creates opportunities for renewal, transformation, regeneration, energy and power, and may offer protection against detrimental influences due to its association with the sun's ability to "rise above" and emanate positive energy or light. It radiates the natural element of "fire," causing one to be more dynamic, quick-moving and expansive.

[1] Veronica Ions, *Egyptian Mythology,* Library of the World's Myths and Legends (New York: Peter Bedrick Books, 1988), 45.

sun's daily movement across the sky. Its burial beneath the earth imitated the sun's setting, and the emergence of the new scarab from the ball of dung duplicated the sun's rising and self-generation.

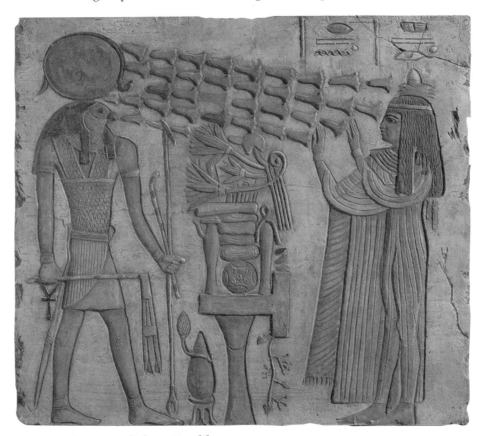

Fig. 6, Falcon-Headed Ra-Harakhte

Placing "Falcon-Headed Ra-Harakhte" in your home or office evokes well-being, vitality, restfulness and grounding due to its association with the setting sun. It helps bring successful closure to projects and situations and may stabilize mood swings.

For this reason, scarabs were often placed as amulets in the linen wrappings of mummies because it was believed this would ensure the continuity of the soul into the afterlife.

As the sun moves from the eastern to the western horizon, it becomes dualistic (remember in sacred geometry, when one point moves away from itself, it becomes two points) and is therefore depicted as two neteroo, Ra and Harakhte. **Fig. 6** shows **Ra-Harakhte** (also known as **Horus of the Two Horizons**) with a male body and the falcon head of the neter **Horus**. He wears a crown comprised of the solar disk (or sun), associated with the neter Ra, encircled by a cobra.

Many cultures believe the sun consists of a life-enhancing force that promotes vitality in all living things. This force is called prana or **qi** (pronounced "chee"). Yogis and martial artists perform specific breath exercises, as well as hand and body postures, to cultivate qi for enhanced health, longevity and development of mental powers. Members of the Egyptian priesthood and royal court regularly practiced forms of yoga and other martial arts that generate qi. They equated qi with solar deities, such as Ra-Harakhte, because qi is a by-product of the sun. When dormant, qi lays at the base of the spine like a coiled serpent; however, when activated it rises up the spine and stands upright like a cobra. Individuals who have fully developed their qi often emanate a radiance around the top of the head that can be seen as a halo of light. Christ, the Virgin Mary, Buddha and various saints are depicted in classical paintings with a halo of qi. Qi moves from the base of the spine to the crown of the head and vice versa, just like the sun moves from one horizon to the other. As it circulates, qi forms a complete circular orbit. Therefore, the headdress worn by Ra-Harakhte has both the

solar disk and cobra encircling it, symbolizing the circuitous path of qi.

In **Fig. 6,** sun rays composed of flower blossoms (representing the generative force of qi) radiate from the solar disk on top of Ra-Harakhte's head. A woman stands before him with palms upraised in order to receive the vital force. Before her is an offering table heaped high with fresh fruits and plants whose growth was supported by the nurturing aspect of qi. Ra-Harakhte holds the ankh and flail in his right hand and the crook and uas scepter in his left hand.

The **crook and flail** are symbols associated with the falcon-headed neter Horus, who was considered the protectorate of the pharaoh. The pharaoh was frequently portrayed with crook and flail to indicate his (or sometimes her) ability to offer assistance to those in need or discipline violators of law.

One pharaoh revered the sun so much that he changed his royal name from Amenophis IV to **Akhenaton.** The name Akhenaton means "**Aton** is pleased"—Aton referring to the celestial body or disk of the sun. Akhenaton revised the existing spiritual and political policy to one that gave exclusivity to Aton over the other neteroo, much to the displeasure of the local priests. His reign was subsequently short-lived and the former doctrine was reinstituted by his successor **Tutankhamon.** Nevertheless, during his reign Akhenaton penned a beautiful poem dedicated to the merits of the sun, named "Hymn of the King to the Sun":

Hymn of the King to the Sun

Beautiful is thine appearing in the horizon of heaven,
thou living sun, the first who lived!
Thou risest in the eastern horizon,
and fillest every land with thy beauty.

Thou are beautiful and great, and glistenest,
and art high above every land.
Thy rays, they encompass the lands,
so far as all that thou hast created.

When thou goest down in the western horizon,
the earth is in darkness, as if it were dead.
When it is dawn and thou risest in the horizon
and shinest as the sun in the day,
thou dispellest the darkness and sheddest thy beams.

The Two Lands keep festival and awake.
All beasts are content with their pasture,
the trees and the bushes are verdant.

The birds fly out of their nests and their wings praise thy ka.
All wild beasts dance on their feet, all that fly
and flutter—they live when thou arisest for them.

Thou hast fashioned the earth according to thy desire,
thou alone, with men, cattle and all wild beasts,
all that is upon the earth and goeth upon feet,
and all that soareth above and flieth with its wings.
Thou puttest every man in his place and thou suppliest their needs.

Thou arisest in thy forms as living sun.
Thou makest millions of forms of thyself alone.

Thou thyself art lifetime and men live in thee.
The eyes look on thy beauty until thou settest.
Thou art in mine heart,
and there is none other that knoweth thee save thy son,
whom thou makes to comprehend thy designs and thy might,
the King of Upper and Lower Egypt,
who liveth on Truth,
lord of the Two Lands, the sole one of Ra,
son of Ra, who liveth on Truth,
lord of diadems, Akhenaton, great in his duration.[2]

[2] Irmgard Woldering, *The Art of Egypt* (New York: Greystone Press, 1963), 149–151.

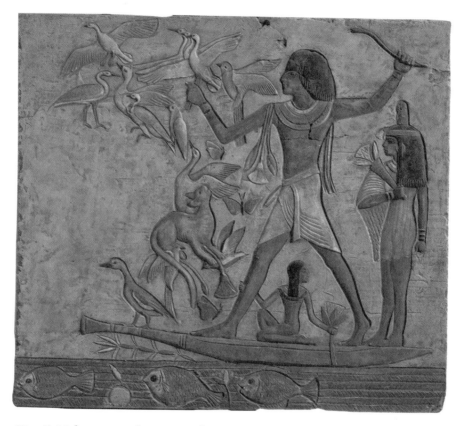

Earth's garden is lush with a multitude of plants, animals, marine life, insects and other life forms. The richness and variety of the Garden of Life are beautifully portrayed in **Fig. 7.** Nebamun, chief physician to Pharaoh Amenhotep II (1436 to 1411 B.C.) who preceded

Fig. 7, Nebamun and His Family Hunting

Placing "Nebamun and His Family Hunting" in your home or office creates an atmosphere of the natural outdoors. It's especially beneficial for those who live in a contained environment (such as a condo) or work in a windowless office. It creates more opportunity to live and work in harmony with the forces of nature and to be supported by them. It may enhance self-control and reduce emotional outbursts.

Tutankhamon by approximately sixty years, is shown in a hunting scene with his wife, daughter and pet cat. He stands in a small **papyrus** boat upon a marsh-filled lake teeming with fish and surrounded by a flock of water fowl. He holds a snake-shaped throwing stick in one hand and wild birds in the other. His daughter picks lotus blossoms while his wife serenely observes. This scene is from Nebamun's tomb and the accompanying text refers to ". . . having pleasure, seeing good things . . ."[3] On the "first level," the scene reflects a family day of recreational sport; however, on the "second level" there's a whole lot more going on in this particular painting.

Perhaps the first clue is the attire of Nebamun's wife. She's shown in her wedding dress, hardly appropriate clothing for a hunting expedition, and an unlikely choice of sport for a honeymoon. Instead, we can surmise that "marriage" in this context refers not only to the relationship between the loving couple, but also the union between Nebamun and nature itself. Most wildlife is just that: wild, untamed and unpredictable. It operates on an instinctual basis. As a part of nature we humans also have fundamental drives and unpredictable emotions within us that can run rampant if left uncontrolled. The rising qi developed through disciplined breath work was seen as a tool to control these powerful internal forces. Subsequently, the snake in Nebamun's hand symbolizes not only his mastery of these natural elements, both internally and externally, but also the ultimate union between them that results in "having pleasure, seeing good things."

Having control of urges and emotions is important; however, it's

[3] John Baines and Jaromir Malek, *Ancient Egypt, The Cultural Atlas of the World* (Alexandria, Va.: Stonehenge Press, 1984), 207.

equally essential that these forces not be totally repressed. The negation of natural urges and emotions often results in deviant behavior or psychological or physical illness. The key is to find a balance between compulsion and negation. It's obvious from texts and paintings that the ancient Egyptians were both a spiritual and earthy people. They freely revealed emotions of love and passion in their poetry and were often depicted singing, dancing, drinking beer and wine, fully enjoying themselves; however, they also had strong moral values that tempered their lust for life and resulted in balance and harmony.

Fig. 8 portrays Pharaoh **Ramses II** and his eldest son Amunherwenemef lassoing a bull. The bull was especially favored as a cult symbol in the city of Memphis and was associated with the neter **Ptah** (pronounced 'peh-tah'). In Memphis, Ptah was considered the Divine architect of the Universe and one of his symbols was the **Apis** bull, denoting virility, stamina and fertility. These qualities were highly revered because they resulted in *life*. Evidently, the totem worked for Ramses as he lived approximately 90 years[4] and fathered as many as 162 children in his lifetime.[5]

Ramses' loincloth is emphasized in this scene where no such emphasis is denoted of his son. This is due to the fact that Ramses is a man—a strong, virile, potent male with the capacity to generate new life whereas his son is only a boy. In fact, Ramses was one of the most powerful pharaohs ever to live and, in addition to offspring, he left an impressive legacy of temples and statuary. The underlying theme of

[4] *Lost Civilizations, Ramses II: Magnificence on the Nile,* (Alexandria, Va.: Time/Life, 1993), 120.
[5] *Time Magazine,* Vol. 146, No. 24 (December 11, 1995).

this scene is that Ramses was empowered with the virility to create life
—not unlike the "gods" themselves.

Special markings had to be present for a bull to be considered Apis.
Specifically, the bull had to be all black with a white triangle on its

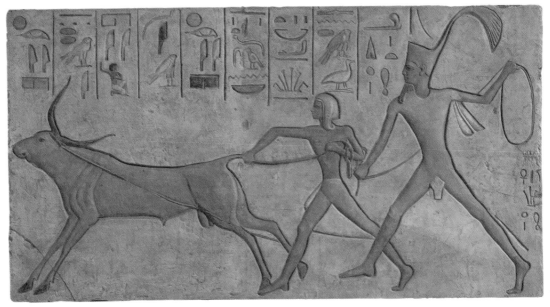

Fig. 8, Ramses II and His Son Lasso a Bull

Placing "Ramses II and His Son Lasso a Bull" in your home or office accentuates masculinity, virility, stamina, progeny and endurance. It's effective for gathering power and forward momentum. It may enhance self-control and reduce compulsive and unhealthy desires.

forehead and a knot under its tongue in the shape of a scarab, among
other considerations. The bull was well cared for and brought out for
public display during important festivities. Upon its death, the bull
was mummified and the search for a new Apis bull began.

In 1851 A.D., a French archaeologist by the name of Auguste Eduard

Mariette stumbled upon an amazing discovery at the ruins of Saqqara near Memphis: an extensive subterranean gallery containing the sarcophagi of twenty-four Apis bulls buried in single blocks of granite weighing between sixty and eighty tons each. Known as the **Serapeum,** this underground chamber was first discovered in the first century B.C. by the geologist Strabo, only to be lost under the desert sands until rediscovered eighteen centuries later by Mariette. Today it remains a popular site for tourists interested in unusual archaeological ruins.

Of all the neteroo, **Osiris** is certainly one of the most revered and well-known. The continuous cycle of birth and death and its paradoxical nature is dramatically portrayed in myths surrounding this powerful icon. Although commonly depicted as a man in **mummiform** symbolizing death, Osiris is also associated with birth and sometimes identified with the bull and the hawk. There's even speculation that Osiris may have actually ruled as a flesh-and-blood pharaoh in the Delta (Lower Egypt) in predynastic times.[6] Pharaoh **Seti I** (the father of Ramses II) built a temple at **Abydos** in Middle Egypt in honor of Osiris, and thereafter it was every Egyptian's goal to make a holy pilgrimage to this sacred site at least once in a lifetime.

In 1999, the Egyptian Department of Antiquities announced the discovery of an underground tomb shaft on the Giza plateau that opens onto the Causeway of Khafre between the Sphinx and second pyramid. The site proved difficult to excavate as it descends nearly one hundred feet in depth in several places and was submerged in water. Dr. Zahi Hawass, Undersecretary of the State for the Giza Monuments and Director of the Pyramids, referred to the extraordinary find as the

[6] Ions, *Egyptian Mythology,* 52.

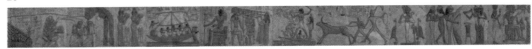

"Tomb of Osiris." Excitement mounted as archaeologists and people around the world wondered what the tomb would reveal. Unquestionably, it would be an even greater archaeological discovery than Tutankhamon's tomb if the mummy of Osiris were to be found. This was unlikely, however, as the ancient Egyptians referred to *every* dead person as Osiris.

ANCIENT PILLARS

After two months of draining water from the shaft, Dr. Hawass found the remains of four pillars surrounded by a wall on the third level of the shaft. Inside was a large granite **sarcophagus** with its lid ajar. Much to Dr. Hawass's excitement, it precisely matched the Greek historian Herodotus's description of Osiris's tomb. Alas, when he looked inside, there was no mummy; however, he did find hieroglyphics for the word "pr," meaning "house." According to Dr. Hawass, in ancient times the Giza plateau was known as "the House of Osiris, Lord of Rastaw," Rastaw referring to underground tunnels. Indeed, there are underground tunnels leading into the shaft; however, Osiris was also believed to control tunnels that lead into the afterlife.[7] Interestingly, many people who have survived death report going through a dark "tunnel" into a bright light.

According to Egyptian mythology, Osiris was the child of the sky goddess Nut. The powerful and sometimes wrathful sun-god Ra was envious of Nut's love for the Earth Geb and forbade her to marry Geb. Nut disobeyed Ra's command and married Geb anyway. Ra was furious

[7] The official Web site of Dr. Zahi Hawass, The Osiris Shaft, *http://www.guardians.net/hawass/osiris1.htm.*

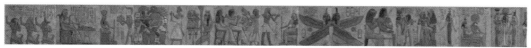

and cast a spell preventing her from bearing children during any given month of the year. **Thoth,** the Egyptian god of wisdom, came to Nut's rescue by winning a seventy-second part of the moon's light in a game of draughts with Ra. This resulted in five intercalary days that were subsequently celebrated right before the calendrical New Year. On each of these consecutive days, Nut gave birth resulting in five neteroo: **Osiris, Isis, Horus (the Elder), Set** and **Nephthys.**

It is said that while in the womb together, Osiris and Isis fell deeply in love. Although brother and sister, they married (as was the custom in royal families of ancient Egypt to keep the bloodline intact) and Osiris assumed the throne of his father Geb. The people of Egypt were uneducated at that time so Osiris and Isis taught them skills such as agriculture, architecture, art, sewing, science, religion and medicine. (Historically, Egypt experienced an inexplicable burst of cultural sophistication approximately fifty-one hundred years ago for which there is no tangible explanation.) The people dearly loved the couple and their popularity spread wide and far. As a result, Osiris began traveling to remote parts of the country to spread the teachings. He gave Isis authority to rule in his absence on his behalf and it's for this reason she wears a headdress decorated with a stepped throne.

Unfortunately, there was one individual who was not happy about Osiris and Isis's newly claimed fame: their brother Set. He was extremely jealous of Osiris and secretly coveted Isis. Being of cunning mind, he devised a scheme to do away with his unsuspecting brother with the aid of seventy-two co-conspirators and the queen of Ethiopia. Upon Osiris's return from an out-of-town excursion, the evil Set

arranged a celebration in which he publicly displayed an elaborately decorated chest. He offered the chest as a gift to anyone who could successfully lie down in it. Unbeknownst to the others, Set had constructed the chest to precisely fit Osiris's measurements. Several guests attempted to recline in it but they were unsuccessful; however, when the unfortunate Osiris climbed into the chest, Set and his accomplices quickly nailed the chest shut and threw it into the Nile River—the chest quickly becoming Osiris's coffin!

Isis was deeply distraught and set out on foot to reclaim Osiris's dead body. She asked everyone she met if they'd seen the chest. After many days, she met some children who told her they'd seen it floating out to sea. Using her powers of divination, Isis determined the chest had drifted to Byblos in Phoenicia where it had become embedded in a Tamarisk tree. Admiring the size and beauty of the tree, the king of Byblos cut it down for use as a pillar in his royal palace. Consequently, Isis allowed herself to be hired as a nanny for the king and queen's newborn baby in order to obtain the pillar for herself.

Unfortunately, the child was sickly. At night, when the boy's mother and father and staff had retired, Isis performed a magical rite, singeing the boy with a sacred flame in order to burn away his dross physical nature and cause him to become immortal. Simultaneously, Isis transformed herself into a swallow and encircled the pillar containing the body of her husband. One evening, quite unexpectedly, the queen of Byblos interrupted Isis in the midst of her ritual, and the queen's fearful shrieks broke the spell. As a result, the boy did not achieve immortality but did recover from his illness. The king and queen were

extremely grateful and offered Isis any treasure of the palace for heal-
ing their child. Although the royal couple thought it very odd, the only
item Isis requested was the wooden pillar supporting the palace. True
to his word, the king immediately cut it down and gave it to Isis. She
returned to Egypt with the chest and secreted it in the Delta marshes
near Buto in order to avoid the vengeful Set.

Set stumbled upon the chest while hunting one evening and in a
rage opened the chest, dismembered Osiris's body into fourteen pieces
and scattered the body parts throughout the kingdom. With the assis-
tance of her sister Nephthys, Isis began the gruesome task of collecting
and preserving her beloved's body. At each site, she held a memorial
service and erected a stela hoping Set would believe she had buried the
body parts on site. She was able to find all of the parts except her hus-
band's phallus, which Set had thrown into the Nile and had been eaten
by a crab. She modeled another, and together with the other body
parts, anointed them with sacred oils and wrapped the entire body in
strips of fine linen. Having done so, Isis spoke words of magic and per-
formed sacred ceremonial rites taught to her by Thoth, the god of wis-
dom, that caused her husband to resurrect from the dead and
impregnate her.

Although Set was unaware that Isis had reconstituted her husband's
body, he was nevertheless upset by the public memorial services she
had performed and threw her into jail as punishment. Once again,
with the assistance of Thoth, Isis was able to escape and conceal the
fact that she was pregnant with Osiris's child. She then took refuge in

the swamps of Buto where she was protected by seven serpents until she ultimately gave birth to their son, Horus.[8]

Needless to say, this myth is very complex. An entire book could be devoted to its many layers of symbolism. Unfortunately, we're unable to go into that degree of depth; however, we can look at some of the more obvious inferences.

At the beginning of the story, Isis and Osiris are "in love" while still in utero. Isis and Osiris represent the **yin/yang** or heart/mind nature of the incarnating soul as it enters into the manifest world in a perfect state of union or love. Love being the highest form of wisdom *and* power, Osiris and Isis are readily recognized as both teachers and compassionate rulers and are adored by the people they represent. As the world of physical form is one of dualistic or opposing forces, the natural tendency is for opposition to occur. In other words, whereas Osiris and Isis emote "good" tendencies such as love, wisdom and charity, their brother Set displays the "evil" characteristics of jealousy, dishonesty and rage. Negative tendencies result in harm, either to ourselves or others, and therefore Osiris is slain by his brother's destructive nature.

Isis sets out to reclaim her husband's body only to learn it was last seen floating out to *sea*. Remember the *cosmic sea* of **Nun**? In other words, Osiris has returned to the void or a state of formlessness; however, the remains of his physical form have become part of a Tamarisk tree. Ashes to ashes, dust to dust—our dead bodies decay and become the fertilizer that supports the continual chain of life on a material level. On a nonmaterial level, the Tree of Life results in the continuation of the immortal soul. This "tree" is referred to by the

[8] Ions, *Egyptian Mythology,* 56–57.

Mayans (who believe the Ceiba tree to be the sacred Tree of Life and also have myths surrounding it) and spiritual traditions such as the Jewish Kabbalah.

In Byblos, Isis becomes nanny to a sickly child. As the netert of love and the archetype of the Divine Mother, it's her responsibility to care for the "child," representing a humanity that has not yet fully matured. In her compassion, she attempts to provide the tools of immortality to her subject; however, the ignorance and fear of the flesh and blood mother of the boy prevents Isis from accomplishing her goal. She is, however, given the inert body of her husband as a gift for healing the child and must accomplish for herself that which she cannot accomplish for humanity at large. In other words, no one can do *it* for *you*; the tools of "ascension" are self-contained.

Opposition to this rite of passage occurs when Set discovers Osiris's body and cuts it into fourteen pieces and scatters it throughout the kingdom. Once again, this is the nature of matter to become divided and dispersed. There is a famous quotation by the neter Thoth that goes something like, *"The 'One' becomes 'two' and the 'two' becomes 'three' and the 'three' becomes all myriad of things."* Remembering the laws of sacred geometry, the cosmology of One (formlessness) is to become two, or dualistic (form), and these elements are intrinsically united, creating three components of Self. This is much like a living cell that divides itself, resulting in replication (or birth) of another organism. And this continually repeats itself from generation to generation, creating the family tree of life until the "myriad of things" is produced. Within the human species, racial, social and geographical

considerations divide us even further until we are "scattered through-out the kingdom" or "dismembered into fourteen parts." A similar theme is reflected in the account of the "twelve tribes of Israel" who wandered the earth following their release from enslavement by the Egyptians. Although there is no historical *Egyptian* account of this event, we can say with authority that in latter dynastic times, there was a decline and deterioration of morality that resulted in the fall of Egypt and this is consistent with the theme portrayed in the dismemberment of Osiris.

The material world is subject to this continuation of duality: life ver-sus death, good versus evil, evolution versus involution. As the neter of dispersion, Set is merely fulfilling a role inherent within the realm of physical matter. On one level, he's evil incarnate; on another, he repre-sents the natural decline that follows the rise of any given thing. This is further exemplified by his wife, Nephthys, who helps Isis collect her husband's body parts. Just as it is the natural disposition of Set to dis-perse matter, it is the natural disposition of Nephthys to collect it. There is, however, a way out of the "catch-22" between opposing forces, and this is symbolized by the magical rite performed by Isis.

At first she attempts to "save" the sickly child (symbolizing an imperfect humanity) by performing the magical rite. The rite is con-ducted by singeing the boy's body with a sacred flame. What is this sacred flame and how may it cause immortality? Logically, it would seem to have the opposite effect and even kill the poor child. The flame, however, is not an ordinary flame. It is created when the downpouring and uprising qi simultaneously circulate from the base of

the spine to the crown of the head and meet in the region of the heart forming a sacred **py-ra-mid** or the pyre (fire) of Ra (of the sun) in mid-body (in the heart). This is created through specialized breathing exercises. Isis transforms herself into a swallow symbolizing the movement of air (the circulating breath) that results when a bird flutters its wings. Isis is thwarted in her efforts to give the child immortality by the fear of the child's mother. Though interrupted, the rite has sufficient effect to relieve the child's suffering, and Isis is granted the gift of her husband's body. In other words, humanity at large may not be ready for these alchemical tools and may react with fear to that which they don't understand. Isis leaves Byblos with her husband's body and acquires the help of Thoth (Divine Wisdom) and performs yet another magical rite on her husband. We know that Osiris and Isis were twin souls, and in love before birth in their mother's womb, therefore symbolizing that they were One. In other words, the suggestion is that this rite must be *self-enacted* in order to unify all factions of self and become "One." This is symbolized by the gathering of the body parts by Nephthys and Isis into one body. The body is then consecrated with sacred oils and white linen representing purity. As a result, Osiris awakens from the dead (symbolizing enlightenment) and Isis becomes pregnant. We know there was no physical sexual act between Isis and her husband because of his missing phallus and the fact that his entire body was wrapped in fine linens; nevertheless, a spiritual union has transpired between them resulting in new life: the birth of Horus. Some traditions commonly refer to this as being "born again."

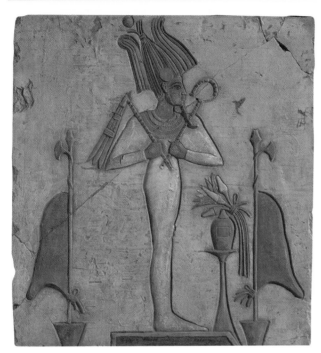

Fig. 9, Osiris in Mummiform

Placing "Osiris in Mummiform" in your home or office facilitates an atmosphere of growth, healing, transformation, renewal and peacefulness. It establishes stability and order and helps to "right" unjust situations. It may also enhance fertility. Meditation on this scene has the potential to invoke insight into higher realms of spiritual consciousness as it naturally reflects the elements of heaven and earth.

In **Fig. 9,** we see the neter Osiris dressed in white mummiform wearing a false beard and plumed headdress with crook and flail in hand. The crook and flail are tools associated with the pharaoh and specific to his role mythologically (and perhaps factually) as a predynastic ruler. His skin is green, symbolic of vegetation and the cycles that plants undergo as they lay dormant in the winter and bloom in the spring. The Egyptians called on Osiris for the success of their crops, believing he had the power to create new growth from infertile or arid soil. He was often associated with the west and the setting sun. Not coincidentally, the most prolific burial sites of the ancient Egyptians are on the west bank of the Nile. He also presided over judging the dead in the afterlife in the **"Weighing of the Heart"** ceremony.

The results of the magical rites performed by Isis are the healing of humanity and tools for self-ascension and immortality. Even if these tools are not yet fully realized, the cultivation of qi has the potential to benefit all living things. For example, food (whether plant or animal) grown in natural conditions has health-enhancing properties because it's imbued with the life force of qi generated from the sun. Similarly, breathing fresh air and spending time in the early morning or late evening sun has a tendency to optimize health. In fact, research has proven that people deprived of sunlight tend to be more susceptible to despondency. Yogis and other martial artists intentionally cultivate qi and some masters of these traditions reportedly live well into their hundreds. They have learned how to generate the "eternal flame," the sacred py-ra-mid or fire in the middle.

The Egyptians believed that some people could achieve this state of self-mastery while living, yet others must go through many cycles of life and death before mastering it. The Mystery Schools were established to help those within the priesthood unveil these

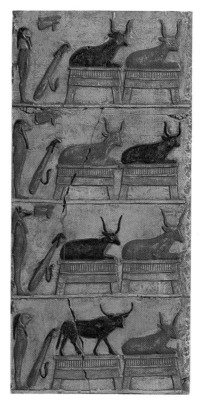

Fig. 10, The Seven Celestial Cows and Bull of Heaven

Placing "The Seven Celestial Cows and the Bull of Heaven" in your home or office promotes good health, vitality and longevity of life. It bestows a protective insulation against adversity and helps create a nurturing atmosphere. It may be useful in gaining insight into unseen realms and awareness of other lifetimes.

esoteric "mysteries" while living. Consequently, many of the scenes painted on temple and tomb walls are of double entendre—for the living **initiate** and for the deceased.

Fig. 10 is one such scene. The Seven Celestial Cows together with the Bull of Heaven are shown with the Four Rudders of Heaven and the **Four Sons of Horus.** When the sun set, it was believed to descend into the underworld. The underworld was not necessarily equated exclusively with the hell realms, although it was not without its share of inherent danger. More so it was geographically oriented because the sun seemingly descended into the bowels of the Earth at night, and it therefore followed reason that this was the course that the soul journeyed upon death. You might recall that in Egyptian cosmology, cows symbolize the nurturing, feminine quality (because of the milk-giving properties of the cow) and bulls symbolize the generative, life-sustaining masculine quality. Therefore, during its nightly descent into the underworld, the sun was both nurtured and sustained by the Seven Celestial Cows and the Bull of Heaven. The Four Rudders symbolize the four cardinal directions as well as a means for the sun to navigate its way through the heavenly spheres. The Four Sons of Horus are protectorates because it was Horus, Isis's son (symbolic of the "new" humanity) who was the avenger of his father's "death," having received the benefit of the special magical rite performed by Isis.

In Egyptian mysticism, it was believed each person ultimately became a shining star following death. Stars are actually living suns. Metaphorically speaking, this symbolizes enlightenment (being illumined and awake!). Therefore, the path of the nightly sun was also

considered the path of the dead. During this dark sojourn, the deceased was nurtured and sustained by the same elements as the sun on its journey into the beyond because they were one and the same. The Four Sons of Horus protected the viscera (the heart, lungs, spleen and liver) of the deceased's body.

But what about the initiate? What role did these elements play if the person was not dead but still living? As discussed previously, when qi accumulates, it emanates a radiance like a living sun. This "sun" moves from "horizon" to "horizon" or from the base of the spine to the crown of the head. During the passage of the qi from "horizon" to "horizon," it moves through seven centers aligned along the spinal column. In Sanskrit, these centers are called **"chakras,"** which literally translates to "spinning wheels of light." (Note: the last syllable "ra" is the Egyptian term for sun.) There is a point when the descending qi meets the ascending qi and this union produces a burst of flame in the heart chakra that results in a state of blissful awareness known as "enlightenment." The path of the qi from "horizon" to "horizon" and the point where it meets in the middle, or the heart, resembles the figure 8. In sacred geometry, eight is the number that represents eternity. Simply put, when the Seven Cows unite with the Heavenly Bull (7 + 1 = 8), the soul emerges anew in a state of eternal bliss and perfection.

3

FOOD OF THE GODS

There is one universal question we all ask ourselves, no matter what our race, creed or culture: "What is the purpose of life?" Or, more specifically, "What is the purpose of *my* life?"

Tenzin Gyatso, the fourteenth Dalai Lama, current spiritual leader and head of state of the Tibetan people and the recipient of the prestigious Nobel Peace Prize, recently responded to this question with the simple but profound answer, *"The purpose of life is happiness!"*

The ancient Egyptians were happy people, according to the Greek historian Herodotus, perhaps happier than any other culture of that time. Handwritten Egyptian

texts extol the virtues of spending days "merrily" rather than being "weary," and nearly all artistic renditions of the Egyptians show them with Mona Lisa–like smiles on their faces during work, play and even in the midst of battle. What was their secret? How did they achieve such a profound level of happiness?

Herodotus revealed that the Egyptians were a very spiritual people. We also know by studying their art and texts that they lived very full and active social lives. Illustrations of daily life show them joyously eating, drinking beer and wine, playing and listening to musical instruments, dancing, hunting, entertaining themselves with board games, performing spiritual rites, attending political festivities, and engaging in various expressions of love and devotion to one another. Incredibly, they somehow managed to find a balance that allowed them to enjoy life without going overboard or compromising spiritual, social or personal morals.

If we, as human beings, are seeds of life in the sacred garden known as planet Earth, what is the fertilizer or food that supports and nourishes our growth? Isn't it, in fact, happiness? And if happiness creates an atmosphere in which we flourish and grow, what is the core cause of happiness? Is it love? Family? Friends? Spirituality? Entertainment? Prosperity? Perhaps by reviewing the legacy of the ancient Egyptians, we may find clues that generate more happiness in our lives today.

COMMUNITY CELEBRATION

According to the records left by the Egyptians, community was considered an important affair. Large groups of people gathered

together in community celebrations for special occasions such as the annual rising of the star "Sothis" at dawn (today thought to be the star Sirius), which coincided with the annual flooding of the Nile River (an especially welcomed event in arid Egypt) and the **heb-sed** jubilee held during the thirtieth year of a **pharaoh's** reign—and every three years thereafter—in which the pharaoh danced and performed a ritual run indicating he was still physically fit to rule despite his age. Pictorial scenes adorning temple and tomb walls depict a plethora of personal, political and spiritual festivities that radiate an atmosphere of joyful living. **Fig. 11** portrays a banquet scene from the tomb of the priest Nakht of Thebes in the Eighteenth Dynasty (Middle Kingdom) in which three female musicians perform with double flute, lute and harp. And in **Fig. 12**, the daughters of Djeser-ka-re-senab prepare for a great festival. The first

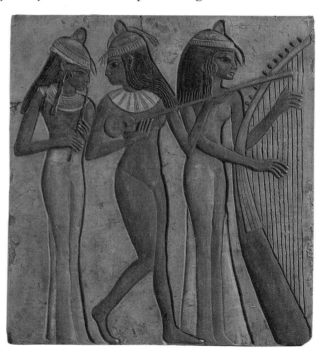

Fig. 11, Female Musicians

Placing "Female Musicians" in your home or office encourages enjoyment of life, leisure and play, and helps promote social ease and opportunity. In addition, it may be beneficial for those interested in developing artistic ability, especially in the areas of music, dance and the performing arts, and creates a relaxed and harmonious environment.

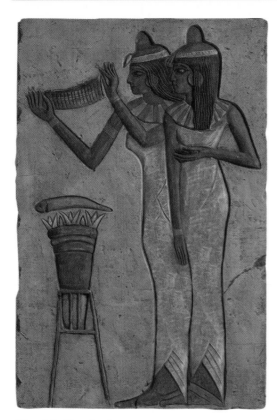

Fig. 12, Festival

Placing "Festival" in your home or office encourages hospitality, generosity, grace, beauty, festivity and social ease, and helps establish a relaxed and harmonious environment.

daughter offers a necklace of adornment to an unseen guest while her sister offers a bowl of liquid refreshment. A vase containing water lilies rests on a stand in front of the two sisters in order to beautify the site.

MUSIC AND DANCE

Music played a large part in the lives of the ancient Egyptians, not only as a means of entertainment, but also as a tool for health and healing. In recent years it's been proven that specific types of music alter brain waves and effect relaxation. In addition, certain tones and sound frequencies such as ultrasound have the capability of shattering or collapsing matter (who could forget the TV commercial with the popular singer who hits a high note and shatters a wine glass) and are commonly used medicinally to remove arterial

and dental plaque. Because of music's ability to promote relaxation, evoke altered states, and encourage harmony and healing, it was viewed as a sacred art by the ancient Egyptians. Paintings on temple and tomb walls portray a variety of dance and music, both as entertainment and spiritual practice.

Fig. 13 from the exquisite Temple of **Abydos** is perhaps one of the most lovely scenes in all of Egypt. In it, the **netert Isis** holds a **sistrum** in her right hand and the **menit** necklace in her left. The sistrum (also called **shesheset**) bears the face of the netert **Hathor** associated with music, dance and personal love. The sistrum itself is a type of musical instrument made of wood or metal, generally in the shape of an **ankh.** Small metal disks like those on a tambourine produce a rattle when the object is shaken that sounds like wind moving through **papyrus** reeds. In fact it's believed the sistrum may have originated with the practice of shaking bundles of papyrus stalks. Not only does the sistrum produce a melodic sound but the ankh shape of the sistrum implies a "life" enhancing quality to the instrument. Possibly this has to do with the generation of **qi** that may be a by-product of hand shaking the instrument as well as the purification of the environment by its resulting sound. It's speculated

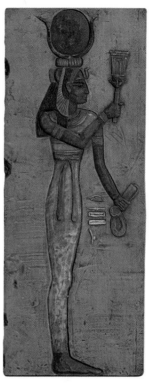

Fig. 13, Isis with Sistrum and Menit

Placing "Isis with Sistrum and Menit" in your home or office evokes love, harmony and vitality, as well as a soft, soothing quietude and peaceful alignment to body and environment. As a symbol of love, Isis enhances both personal and spiritual relationships.

that the menit necklace may also have been used musically as a kind of percussion instrument. Like the sistrum, it's associated with the netert Hathor and seems to have functioned as a tool to transmit energy (or qi) to a specified recipient, usually the **initiate** or pharaoh. We know by virtue of the fact that the netert Isis is a part of this scene that the performance is spiritually focused and not a social function.

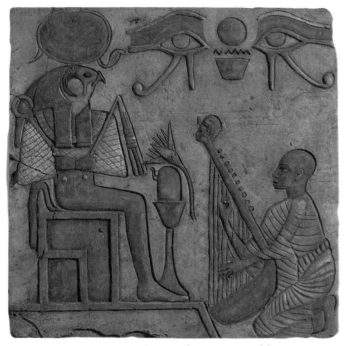

Fig. 14, Musician Kneeling Before Ra-Harakhte

Placing "Musician Kneeling Before Ra-Harakhte" in your home or office promotes peace, harmony, humility, devotion, appreciation, duration, Divine guidance and vision, and protection from adversity.

A male musician plays the lute while kneeling reverently before the **neter Ra-Harakhte** in **Fig. 14.** As with the previous scene, this appears more as an act of devotion rather than entertainment and may be equated with the organist who performs in church on Sunday morning in praise of the Divine. Above them are the two eyes of **Ra** known as **udjat.** The right eye is associated with the sun and the left eye with the moon. A number of myths

refer to the eye being swallowed or damaged by the adversarial neter **Set** and subsequently restored. This may, in fact, symbolize the waning and waxing of the moon and/or the setting and rising of the sun.

Udjat were frequently painted on the left side of coffins serving as a window for the deceased to "see" the way into the celestial realms and also on the bows of boats to assist in "seeing" ahead. Furthermore, jewelry and amulets frequently bore the emblem of the eye and served as talismans to protect the wearer. Have you ever noticed that a one-dollar bill bears a pyramid with an udjat in the capstone on the back of the bill? According to the U.S. Department of Treasury, "The pyramid on the Great Seal symbolizes strength and durability. The unfinished pyramid suggests the United States will grow, improve and build. In addition, the 'All-Seeing Eye' located above the pyramid suggests the importance of divine guidance in favor of the American cause."[1]

Meditative dance incorporating specific hand and body postures to cultivate qi for self-defense, good health and the development of non-ordinary powers was regularly practiced in ancient Egypt. Today, similar arts such as yoga and the martial arts, continue to be developed worldwide. In fact, there are many documented cases of masters of martial arts from differing cultures who perform feats such as the alteration of the properties of molecules and atoms under scientific laboratory conditions and the instantaneous healing of chronically ill patients by directing qi from both short and long distances.[2] **Fig. 15** shows Pharaoh **Ramses I** dancing in a squatting posture between two powerful "spirits" Pe and Nekhen during the king's jubilee. The spirits represent the tradition of dual rulership in Upper and Lower Egypt as well as the

[1] U.S. Dept. of Treasury Web site, *http://www.treas.gov/opc/opc0034.html#quest19*.
[2] *http:www.qigong.net/english/science/index.htm*

dance between two energetic forces within the dancer's physical body. The neter Pe represents the force of qi (solar or **yang** force) and Nekhen the force of **kundalini** (earth or **yin** force). The combination of these forces promotes the power necessary for effective rulership of one's own personal body and, in the case of the pharaoh, a larger body incorporating all of the people of Egypt itself. The scene celebrates the rejuvenation of the pharaoh's **ba** or soul. The specific stance of the three dancers is called the **henu,** a culmination in a series of ceremonial

Fig. 15, Ramses I in Jubilee Dance with Pe and Nekhen

Placing "Ramses I in Jubilee Dance with Pe and Nekhen" in your home or office celebrates achievement, victory and harmonious partnership, and evokes power, longevity, good health and stamina.

gestures known as the "Recitation of the Glorifications." The performer knelt on one knee with arm extended and hand open while holding the other arm with closed fist crooked back toward the body. The extended arm was then drawn back and the fist closed. The chest was then touched or struck with alternating blows from the closed fists. A similar scene from the Eighteenth Dynasty temple at Buhen in Nubia depicts the neter Pe in the henu stance with accompanying text that reads, "May they give all life and power . . . all stability which they have," indicating the vitalizing properties of the henu.

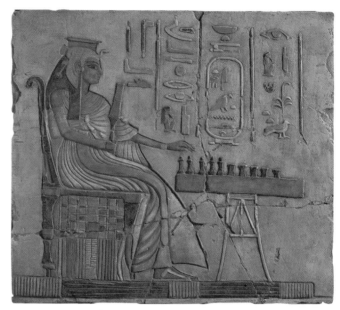

Fig. 16, Queen Nefertari Playing Senet

Placing "Queen Nefertari Playing Senet" in your home or office stimulates mental focus, power, positive resolution to challenge, solitude, enjoyment and leisure.

The light pounding on the chest performed in the henu may create a biochemical release from the thymus gland that stimulates the immune system, resulting in enhanced health. It goes without saying that the practice of regular exercise, and especially martial arts such as qigong and tai chi, has proven to result in better

health. Good health provides yet another opportunity for greater happiness. We've all heard the old expression, "When you have your health, you have it all!"

RECREATION

A common recreational pastime of the Egyptians was a board game called **senet.** No one knows exactly how the game was played, but it was a favorite among schoolchildren, scribes, queens, kings and laborers alike and prevailed from early to late dynasties. It was even placed in tombs for the deceased to enjoy in the afterlife. The senet board had thirty squares upon which flat and conical pieces were moved. **Fig. 16** shows the beautiful Queen **Nefertari** of the Nineteenth Dynasty engaged in the popular game.

FOOD

No one could disagree that food plays a large role in our lives. A great deal of energy and effort is spent in cultivating, buying, preparing, cooking, serving and enjoying the foods we eat. There is an old expression, "You are what you eat." The quality of the food and the types of food we eat often affect the way we look and feel. A home-cooked meal is frequently more satisfying than a fast-food meal. But why? Why does a home-cooked hamburger taste better or worse than a fast-food hamburger? Could it be that the thoughts of those preparing the food actually impact the food itself? What if the cook in the fast-food restaurant is harried and stressed, dissatisfied with the job and low pay? Could these

feelings be imparted to the food itself? Mealtime prayer was established not only as a means of expressing gratitude for the food we eat, but also as a means of transmuting stress or negative emotions associated with the killing of the animal intended as a food product and any negative thoughts that may result during food preparation.

Many religions offer ceremonies in which food and wine are blessed and then shared by the congregation. It is believed that blessing the food in this way results in a higher degree of physical and spiritual nourishment. There are many scenes depicted on Egyptian temple and tomb walls of food being served by the high priest or pharaoh to various "gods" and "goddesses." Although we can't say for certain, it seems highly unlikely that the food was ever eaten. After leaving the food on the altar day after day and finding the food uneaten, what purpose could this ritual have served, if not as a reminder that imbuing food with love results in more love and spiritual nourishment for ourselves?

Fig. 17 shows Pharaoh **Seti I** offering a tray of food beautifully arranged and heaped high with breads, fruits and meats to the netert of love, Isis. The theme of this scene is that the food is an offering of love to love (the netert Isis). When food is offered in love, love is reflected back and imbues nourishment to the body and the soul of the partaker of that food. In other words, it's not only the food that nourishes but the love contained within it.

In many cultures, the affluence of a family or community is determined by the abundance of food. Despite the challenging agricultural conditions of Egypt, food was generally plentiful as evidenced by the many scenes in which trays of vegetables, fruits, fish, fowl and meats

are displayed. In **Fig. 18,** we see a variety of foods commonly offered to guests and gods alike.

FRANKINCENSE AND MYRRH

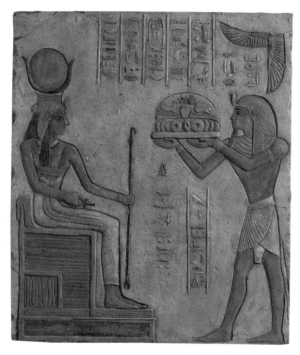

Fig. 17, Pharaoh Seti I Offering Food to Isis

Placing "Pharaoh Seti I Offering Food to Isis" in your home or office establishes a bridge between the physical and spiritual realms (heaven and earth) to create nourishment and fulfillment in both body and soul. This scene may also be useful in helping discover purposeful ways in which to serve others without feeling burdened or resentful.

In her ninth regnal year, Queen **Hatshepsut,** ruler of Egypt from 1503 to 1480 B.C., sent a fleet of five sailing vessels on a trading expedition to the "Land of Punt" near present-day Somalia. The ships returned laden with flora, fauna, frankincense, myrrh, sweet-smelling resins and fragrant ointments to be used for cosmetics and religious purposes.[3] These items were considered very precious, and their acquisition granted Hatshepsut much favor from the priests and public. As in ancient times, frankincense and myrrh continue to be used today as incense for purifying churches, temples and

[3] *Ancient Egypt: Discovering Its Splendors,* 223.

personal dwellings. The Egyptian priest Penmaat offers incense to the neter **Amon** in **Fig. 19,** the fragrant smoke rising from a small container held in his right hand.

PRAYER

The word **Amon** literally means "the Hidden One." There is a strong similarity between the neteroo Amon and **Atum** in that they both represent the emergence of the Divine (formlessness) into matter (form). Perhaps the only difference between the two is that emphasis is placed on the state that precedes form with Amon (the "Hidden One"), whereas with Atum, the emphasis is placed on the resultant state of form itself (or the "atom," the building block of all matter).

Variations of the name Amon further reveal its universal applicability. Today the word "Amen" is commonly used to conclude a prayer. This gives the prayer the

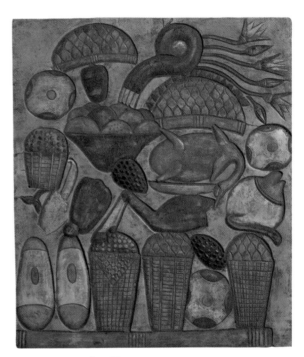

Fig. 18, Food Offering

Placing "Food Offering" in your home or office establishes an atmosphere of abundance, nourishment, fulfillment and healthy eating habits.

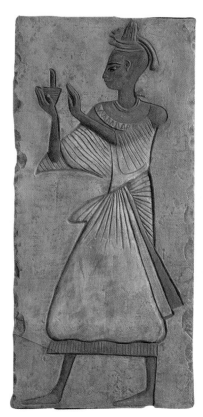

Fig. 19, The Priest Penmaat Burning Incense

Placing "The Priest Penmaat Burning Incense" in your home or office creates sacred space, purification, transformation and spiritual renewal.

power to be fully realized or to come into manifestation. Another variation is the Sanskrit word "Aum," which is closely related to the word "Om." The word "aum" is used by both Hindu and Buddhist traditions alike to express the concept of form emanating from formlessness. This concept is visibly expressed in the sacred geometry of the letters of "O" and "m." The "O" geometrically symbolizes the void (zero, infinity) and the "m" geometrically expresses sound vibrations that move in a wavelike fashion (mmm-mmm) out of the void, resulting in the manifestation of matter. Thus, Om is known as a sacred Word of creation. All matter is fundamentally dualistic in nature and expresses itself in male/female or yin/yang components. Therefore, Om/Aum are intrinsically related, Om representing the yang (masculine, physical, overt) aspect and Aum representing the yin (feminine, spiritual, hidden) aspect. This same relationship is expressed through the neteroo Amon and Atum.

The worship of Amon remained steady in ancient Egypt (particularly in Thebes) until briefly interrupted by Pharaoh **Akhenaton** in the

late Eighteenth Dynasty. It's probable that his unpopular religious views ran contrary to the powerful priesthood of Amon and resulted in his untimely demise. The next pharaoh in succession to the throne, the young boy-king **Tutankhamon**, restored Amon-worship.

JEWEL OF THE NILE

Egypt has often been referred to as both "the jewel of the Nile" and "the gift of the Nile." The annual flood of the river enriched the land, irrigating and fertilizing crops with water and silt, producing a plentiful yield. When food was abundant, the people were happy and lived well. Largely dependent upon the Nile, they associated it with prosperity. **Fig. 20** depicts the neter of the Nile River, **Hapi**, kneeling with a tray of food in his right hand and two water plants in his left representing the upper and lower Nile. He's portrayed as a bearded man with blue skin, the color of the Nile waters. His breasts

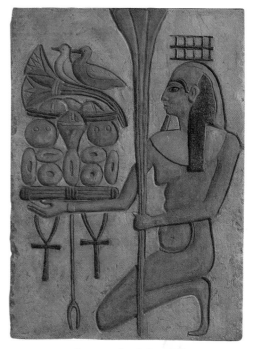

Fig. 20, "Blue God of the Nile, Hapi, Offering Food"

Placing "Blue God of the Nile, Hapi, Offering Food" in your home or office promotes prosperity and abundance, a natural flow of energy and movement. It may also enhance fertility and creativity. This piece may be especially helpful for those who lack water in their environment (i.e., no lakes, rivers, or other bodies of water such as lily or fish ponds, fish tanks, water fountains, etc.) in restoring the natural balance of elements.

are pendent, symbolizing the fertile nature of his being, and his belly protrudes like a fat Buddha, emphasizing that he is well-nourished and content. In fact, the name Hapi is pronounced "happy" and reflects the emotion felt when we are abundantly provided for and very content. Hapi was sometimes regarded as two "gods": the god of the south Nile and the god of the north Nile, who together performed the **samtaui** ritual, the unification of the Two Lands. He was also identified with the celestial river upon which the deceased sailed into the heavens.[4]

FAMILY AND HOME

Wealthy families in ancient Egypt enjoyed many of the privileges of wealthy people today. An architectural model from the ancient ruins of an Amarna suburb details a mini-estate composed of sun-dried bricks and a tiled floor situated on a three-quarter-acre lot. The estate is enclosed for privacy and the main entry guarded. A separate entry and servants' quarters are provided with adjoining kitchen and stable. The main quarters consist of one big central room with an adjacent master bedroom and smaller sleeping quarters for the rest of the household. The master bedroom is complete with an anointing room, shower stall and contoured stone toilet seat. Outside is a garden, well, cattle pens, grain bins, porter's lodge and chapel.[5]

Although there is evidence of sophisticated plumbing utilizing copper piping and metal fittings in some temples where water played an important part in purification rituals (such as the mortuary temple of King Suhura at Abusir), the majority of the nobles' homes utilized simple

[4] Ions, *Egyptian Mythology,* 106–108.
[5] *Ancient Egypt: Discovering Its Splendors,* 110.

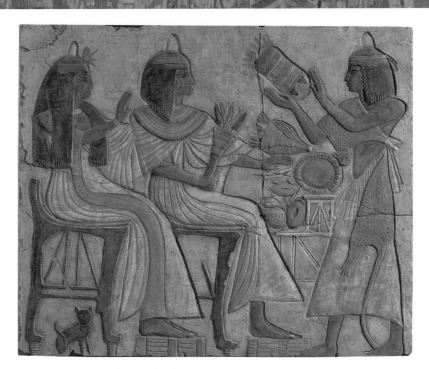

Fig. 21, Ipuy and Family Banquet

Placing "Ipuy and Family Banquet" in your home or office promotes family unity, prosperity, leisure, respect between generations, sharing of and gratitude for food and material comforts, communion and communication.

drainage systems. As an example, servants poured water over the bather in the bath or shower stall and the water drained from the outlet into a vase perforated at the bottom and cemented into the earth. In other instances water drained through an earthenware channel in the wall that emptied into a bowl outside that had to be emptied by hand. Toilets emptied into the sandy soil.[6] Even some of the workers' quarters on construction sites at pyramids and temple complexes had drainage

[6] *Plumbing and Mechanical,* (July 1989).

systems that led underground to the river. Most of the people lived in two- to three-story townhouses with the first floor reserved for businesses.

One of the favorite pastimes of the wealthy was to hold parties for family and friends in which food was lavishly presented along with beer, wine, music, acrobats and other entertainment. The finest linen clothing and jewelry made out of gold, silver, electrum (a combination of silver and gold), and semiprecious stones such as turquoise, lapis lazuli, carnelian, garnet, onyx and jasper adorned both men and women alike on special occasions. Such an event is portrayed in **Fig. 21,** where the prominent sculptor Ipuy and his wife greet their son and daughter-in-law (the daughter-in-law is truncated from the scene) for a sumptuous banquet. Each wears a cone of perfume on top of the head, which fragrantly effused as it melted in the heat. As we might do today, the guests bring gifts for the hosts. All wear fine linen garments and jeweled or beaded collars called **wesekh** and, in addition, the son wears a leopard skin indicating his position in the priesthood. Even the family cat (beneath Ipuy's wife's chair) joins in the fun!

LOVE

Much like today, the majority of ancient Egyptians valued love more than wealth. Love in all its many facets—Divine love, romantic love, family love and love for life itself was expressed through poetry, painting, sculpture and architecture throughout upper and lower Egypt. A pharaoh always took special care when building a temple or tomb to

acknowledge the neteroo of love. Although different aspects of love are represented by different neteroo, perhaps the most universal and widely known is Isis. Even in current times, she is widely regarded as the "goddess of love." Isis, however, plays an even greater role than goddess as she is also wife to Osiris and the Divine Mother who mys-

tically conceives the child **Horus** subsequent to her husband's death. This myth originated well before the time of the immaculate conception of the Virgin Mary and is a common theme in other religions and cultural myths. In addition to goddess, wife and mother, Isis is sister to **Nephthys**, Set, **Osiris** (also her husband) and Horus (often referred to as **Horus the Elder** to differentiate from the role of Horus

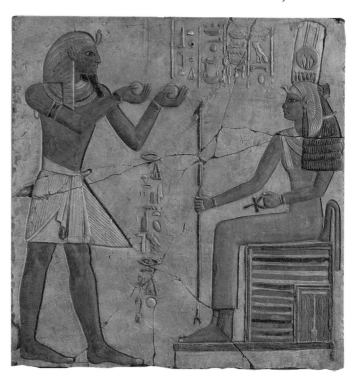

Fig. 22, Isis Receiving Offering of Wine from Seti I

Placing "Isis Receiving Offering of Wine from Seti I" in your home or office evokes spiritual reconciliation and communion with the Divine, humility and gratitude for one's blessings, and appreciation and respect for the feminine creative principle expressed through all forms of life.

Fig. 23, Winged Goddesses Isis and Ma'at

Placing "Winged Goddesses Isis and Ma'at" in your home or office promotes love, creativity, protection, truth, balance, harmony, order and higher consciousness. This scene reflects the element of air and is particularly useful for unimpeded movement of thought and energy.

the devoted son). In addition, she is Queen of Egypt. In other words, Isis is all things feminine: goddess, wife, mother, sister and queen. And yet, in her own words, she states, "No mortal man has ever lifted my veil!" This is similar in context to the Buddhist parable, "If you meet the Buddha, kill him." Like the Buddha, Isis is reflected in various archetypal personas; however, she is not those personas themselves. Isis is love and this love is reflected in all of the various relationships we share with others!

In **Fig. 22,** Isis receives an offering of wine from Pharaoh Seti I. She is seated on the royal throne, symbolizing the concept that love rules, or in other words, love is the highest power. She holds the **uas,** scepter of the neteroo, in her right hand and the ankh of life in her left. Seti's skirt is stiffly starched, reflecting the formality of the occasion. The design on his skirt mimics the shape of a pyramid, which in turn mimics the geometric shape of the sun's rays as they reflect light to earth.

The netert Isis is again depicted in **Fig. 23,** kneeling with winged arms back-to-back to the netert **Ma'at** in reverse image. Winged goddesses were often placed over lintels in tombs and temples to protect, watch over and guide the inhabitants associated with the particular structure (i.e., the pharaoh, the royal family, the priesthood or the deceased). It was believed that the winged goddess, as a representation of the Divine, assisted the deceased safely into the heavenly realms. The "wings" also assume the shape uprising qi forms around the body when specific breathing practices are employed. No doubt the Egyptian priesthood was fully aware of this phenomena as they were masters of yoga, a meditative art that employs specialized breathing techniques. Isis wears the stepped-throne crown signifying her "authority to rule" while the steps symbolize the "stairway to heaven."

The netert Ma'at kneels beside Isis in identical reversed pose. She wears the white ostrich feather called **shu** (air) in her crown. During **initiation** and upon death, Ma'at ushers the individual into the **Hall of Truth** whereby her feather is placed upon one side of a scale and the heart of the initiate or deceased on the other. If the scales balance, the individual is said to be "justified," "true of voice."[7] If not, the guilty

[7] Ions, *Egyptian Mythology,* 113.

heart is greedily devoured by **Ammit,** a monstrous creature who sits near the double scales of truth waiting for his next meal.

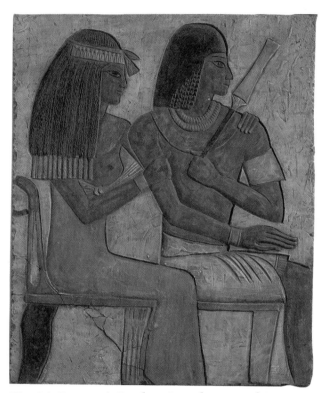

Fig. 24, Ramose's Brother Amenhotep and His Wife May

Placing "Ramose's Brother Amenhotep and His Wife May" in your home or office generates love, loyalty, affection and equality. It promotes a healthy relationship between a couple and strengthens the institution of marriage.

Ma'at symbolizes truth, balance and order. Without Ma'at, utter chaos reigns. All of the neteroo govern by principles of Ma'at. As the pharaoh was considered a representation of the neteroo, he, too, must rule by Ma'at in order to ensure balance, order, and a just and harmonious kingdom.

One of the most beautiful tombs open to the public today in the Valley of the Nobles is that of the vizier Ramose. This important official served two pharaoahs in the Eighteenth Dynasty, Amenhotep III (1390 to 1352 B.C.) and Akhenaton (1352 to 1336 B.C.). Exquisitely carved and painted scenes of Ramose and his wife and family members grace the walls of the tomb. **Fig. 24**

is a lovely portrait of Ramose's brother, Amenhotep and his wife May, from the east wall of the tomb. The loving couple are seated side by side as the wife adoringly encircles her left arm around her husband's back and shoulder, her right hand gently clasping his left forearm. Although there is some confusion regarding Ramose's family tree, it is thought that Amenhotep was Ramose's half-brother, overseer of the city of Memphis, and that Amenhotep's daughter was Ramose's wife.

If the love of another was desired but not reciprocated or a marriage ran into trouble, prayers and offerings were made to the netert Hathor. Like Isis, Hathor is considered a netert of love, however, she was often entreated to assist in matters of personal love whereas Isis was associated more with the love of humanity as a whole. Often portrayed in the form of a cow or as a woman wearing the horned disk, Hathor is affiliated with romance, sensuality, fertility, beauty, music and dance. Queen Nefertari dedicated a temple at Abu Simbel to the **netert** Hathor while her husband Pharaoh **Ramses II** erected a temple at the same site to Hathor's husband, the falcon-headed Horus. Likewise, the Temple of Horus at Edfu was spiritually connected to the Temple of Hathor at Dendera. Once a year, priests removed the statue of Hathor from the temple at Dendera and transported it on a ceremonial barge to Edfu, purportedly for a conjugal visit between Hathor and her husband Horus. Every evening the two statues were placed together in the mamissi or birthing room. At the conclusion of the visit, the statue of Hathor was returned to its residence at Dendera.

Hathor is beautifully represented in **Fig. 25**, holding hands in what can only be described as a very personal exchange between herself and

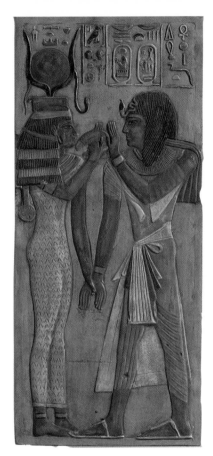

Fig. 25, Hathor Offering Menit Necklace to Seti I

Placing "Hathor Offering Menit Necklace to Seti I" in your home or office generates love and harmony between a couple as well as generosity, sensuality, fertility and potency. It can help one experience the beauty in all things and more fully enjoy life.

Pharaoh Seti I. She offers Seti the menit necklace with her right hand (the hand of giving) as he solemnly accepts it with his left hand (the hand of receiving). In fact, both Hathor and her son bore the epithet "Great Menit," and she is often shown both wearing and offering the necklace to the king. Even when depicted in the form of a cow, Hathor frequently wears the necklace around her neck. Exactly how the necklace functioned is somewhat of a mystery, but it was thought that the essence of the goddess was transmitted through the necklace itself. As such, it is associated with love, birth, renewal, fertility and potency. This was important to the pharaoh as it was essential that he maintained his potency as ruler, was loved by the people and that his terms of office were renewed. The king is also frequently portrayed offering the menit to the goddess as well, symbolizing the reciprocity of love.

When a netert is shown wearing the horned disk as a headdress, she reflects the nurturing aspect of a cow. When a neter is shown wearing the same, he reflects the power and potency associated with a bull.

Depending on the particular scene, neteroo frequently wear different headdresses that elucidate their specific role in the scene. In **Fig. 26,** Isis is shown wearing the horned disk headdress. Although her traditional headdress is that of the stepped throne, she is often shown wearing the horned disk, which is more commonly associated with the goddess Hathor. Unless skilled in the reading of hieroglyphics, it's difficult to determine a particular goddess from another as they may look similar and wear identical headdresses. In this scene, the emphasis is on Isis's role as "mother" rather than "queen." Therefore, the horned disk symbolizes the nurturing milk

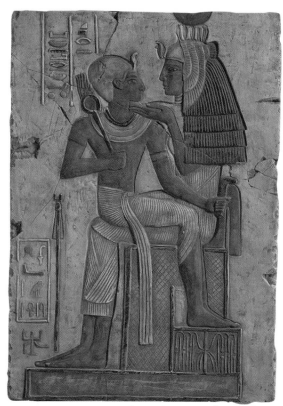

Fig. 26, Seti I Seated on the Lap of Isis

Placing "Seti I Seated on the Lap of Isis" in your home or office establishes a strong bond between mother and child and self and the Divine Mother, and promotes unconditional love, comfort, nurturing, sustenance and acceptance.

of the heavenly cow (or the nurturing love of the Divine Mother). The child in her lap is Pharaoh Seti I. Seti holds the **crook,** emblem of the compassionate pharaoh, in his right hand and wears a pleated ceremonial skirt, broad collar and golden cap with **uraeus.**

4

THE HALL OF TRUTH

As life unfolds, we experience certain events that assess, reflect and celebrate our growth and accomplishment. These rites of passage are formally acknowledged through rituals such as birthdays, graduation, marriage, retirement, death, and various educational and religious ceremonies. In the ancient mystery schools there was a formal system to evaluate, guide and mold the student into various rites of passage called **initiation** that ultimately resulted in the student's intellectual and spiritual refinement. The Egyptian priesthood was vigorous in this practice and became renowned for the adepts who emerged from it.

Initiation rites not only assessed the student's accumulated wisdom, will and merit,

but helped transform characteristics that proved less than the ideal standard. Inadequacies were transformed through the catharsis of the initiation itself or with the guidance of **neteroo** and the priesthood. Therefore, initiation was perceived as an honor, a challenge and, ultimately, a process of transformation.

Although there is no historical proof, it's believed that many foreign scholars underwent rites of initiation in the Egyptian mystery schools and subsequently adapted the teachings to the Greco-Roman world and Renaissance Europe. In fact, some of the world's greatest philosophical writings are thought to have either originated in ancient Egypt or to have been influenced by the Egyptians. One such document is the *Corpus Hermeticum,* a collection of philosophical and mystical treatises by anonymous authors. Its merits are extolled by Plato in *Timaeus* and similar dialogues. "Hermeticum" comes from "Hermes," the Greeks' name for **Thoth,** the Egyptian **neter** of wisdom.

Myths of the magician-priests alchemically turning base metal into gold were surely a metaphor for the transformation of the **initiate** into an illumined being, or "a precious jewel." The Egyptians believed this transformation was not unlike the experience of death itself. As the mortal body (or "base material") is shed at the time of death, the soul emerges into a new body of light ("gold" or the "jewel"), a light so brilliant as to never diminish nor be extinguished. Consequently, rituals such as the recitation of hymns, prayers and magical incantations were used both in funerary rites as well as rites of initiation because the practice was thought to result in enlightenment. In the latter dynasties, these rituals were not only performed in the secrecy of the priesthood

but by the general populace at large. Whether the public fully comprehended the deeper meaning of the rituals is questionable; however, the practice served to establish a fertile ground for the eventual awakening and maturation of the self-realized soul known to the Egyptians as the **khu.**

These ritualistic tools were presented as funerary practices for simplicity's sake; however, it should be noted that death was *not* a necessary component of the procedures. The study and reading of texts, magical incantations, and other practices were performed by both the living and presumably the deceased as evidenced by instruction to both in the ***Book of Coming Forth by Day.*** The instructions are complex and camouflaged in symbolism that prove difficult, if not impossible, to fully understand on a first-level basis and therefore must be addressed through meditative or mystical means.

It's not uncommon today to hear stories about people who hovered close to death or actually experienced death, but were resuscitated within a few moments. From a vantage point outside of the physical body, they report moving rapidly through a dark tunnel or hallway and into a bright light. Images of life experiences flash before their eyes in a matter of seconds. Based on these experiences, many have a deeper insight into the purpose of their life and willingly choose or are guided to return to complete unfinished business.

The ancient Egyptians believed something similar transpired at death. They asserted that the deceased was escorted by neteroo on a barge that sailed through the **duat,** a dark and sometimes treacherous passageway or tunnel that led from the underworld into the heavens.

This dark tunnel was thought to be the same path that the sun god **Ra** transversed after setting in the evening and before his ascension the following morning. During the course of passage in the duat, Ra daily battled the evil serpent **Apep** who attempted to block the sun's passage and diminish its light. Sometimes Ra was severely challenged and the result was stormy weather; or if Apep swallowed Ra an eclipse resulted. Inevitably Ra prevailed in the battle against the serpent and emerged the victor. The conflict between Ra and Apep symbolizes the conflict between light and dark—or good and evil—that must be successfully resolved on a day-to-day and life-to-life basis in order for ascension and illumination to ultimately occur.

Admittance of the deceased or initiate into the heavenly realms was preceded by the judgment of forty-two neteroo or assessors in the **Double Hall of Truth.** Also known as the **Hall of Ma'at** (as it was the **netert Ma'at** who presided over matters of truth, justice, law, balance and divine order), the Double Hall of Truth was located between the fifth and sixth division of the duat. The formal interrogation process itself was known as the "negative confession" because it was believed that a person of good, moral integrity would answer negatively (or "no") to each question. The Egyptians considered the inquiry so critical that they offered a "cheat sheet" of the forty-two questions to be studied prior to death, copies of which were inscribed on scrolls, tombs and coffins. An Eighteenth Dynasty translation from the *Book of Coming Forth by Day* follows:

 1. I have not done iniquity.

2. I have not robbed with violence.

3. I have not done violence to any man.

4. I have not committed theft.

5. I have slain neither man nor woman.

6. I have not made light the bushel.

7. I have not acted deceitfully.

8. I have not purloined the things which belong to God.

9. I have not uttered falsehood.

10. I have not carried off goods by force.

11. I have not uttered vile (or evil) words.

12. I have not carried off food by force.

13. I have not acted deceitfully.

14. I have not lost my temper and become angry.

15. I have invaded no man's land.

16. I have not slaughtered animals, which are the possessions of God.

17. I have not laid waste the lands which have been ploughed.

18. I have not pried into matters to make mischief.

19. I have not set my mouth in motion against any man.

20. I have not given way to wrath without due cause.

21. I have not committed fornication, and I have not committed sodomy.

22. I have not polluted myself.

23. I have not lain with the wife of a man.

24. I have not made any man to be afraid.

25. I have not made my speech to burn with anger.

26. I have not made myself deaf unto the words of right and truth.

27. I have not made another person weep.

28. I have not uttered blasphemies.

29. I have not acted with violence.

30. I have not acted without due consideration.

31. I have not pierced my skin and I have not taken vengeance on the god.

32. I have not multiplied my speech beyond what should be said.

33. I have not committed fraud and I have not looked upon evil.

34. I have never uttered curses against the king.

35. I have not fouled running water.

36. I have not exalted my speech.

37. I have not uttered curses against God.

38. I have not behaved with insolence.

39. I have not been guilty of favoritism.

40. I have not increased my wealth except by means of such things as are mine own possessions.

41. I have not uttered curses against that which belongeth to God and is with me.

42. I have not thought scorn of the god of the city.[1]

That the number of assessors and questions asked equals forty-two was no doubt of special significance to the ancient Egyptians. This may have referred to the forty-two nomes or provinces of Upper and Lower Egypt; however, it's also possible the symbolism may have a more mystical implication. It is well known that the Egyptians placed a great deal of value on numbers. Numerology is the ancient art of numbers

[1] Anthony S. Mercatante, *Who's Who in Egyptian Mythology* (New York: Clarkson N. Potter, Inc., 1978), 103–104.

and how they reflect certain aptitudes and character tendencies that express the mechanisms of the cosmos itself. In numerology, numbers are added together to arrive at a single-digit base number. Forty-two therefore becomes 4+2=6, six being the base number. The number 6 in numerology symbolizes karma, responsibility, harmony and balance, qualities all associated with the netert Ma'at. Interestingly, the *Tibetan Book of the Dead* also makes reference to forty-two benevolent deities (as well as fifty-eight wrathful deities) perceived by the deceased in the bardo, which is described similarly to the Egyptian duat.[2]

The hearing in the Double Hall of Truth was held in two parts, the first consisting of the negative confession presided over by Ma'at and the second consisting of the **Weighing of the Heart** conducted by Thoth. In some myths, Thoth and Ma'at were husband and wife symbolizing the marriage between wisdom and truth; in other myths **Shesat** (the feminine netert of wisdom) was designated as Thoth's wife. Shesat is most commonly represented as a woman wearing a star headdress recording the results of the actions (karma) of the deceased or initiate on leaves of the sacred Persea tree, the Tree of Life.

Once the deceased or initiate answered the forty-two questions in the negative and affirmed purity of heart (subsequently confirmed by weighing the heart on the Scale of Justice against the Feather of Truth), he or she must also recite the secret names of the forty-two assessors. Upon doing so, the deceased or initiate was considered "true of voice" and "justified."

The proceedings in the Double Hall of Truth were therefore twofold: the first assessing the purity of the *actions* of the individual and the

[2] *The Shambhala Dictionary of Buddhism and Zen* (Boston, Mass.: Shambhala Publications, 1991), 17.

second assessing the purity of the *heart*. It's evident that the ancient Egyptians believed it unlikely anyone could answer all forty-two questions without misstating the facts. Who amongst us has not become angry, exaggerated or made another cry—all actions that had to be categorically denied in the Hall of Truth in order to successfully graduate to the heavenly realms? This is emphasized by "cheat sheets," which were memorized in advance in order to answer the forty-two questions correctly. Spell 30B from *The Book of Coming Forth by Day* is a formal appeal to the heart "not to betray" its possessor to the judges:

> *O my heart of my mother! O my heart of my mother! O my heart of my transformations! Do not stand up against me as a witness! Do not create opposition to me in the council! Do not cause the pan to sink in the presence of the keeper of the balance!* [3]

The message here is that there are *two* truths: the appearance of things (how *we* judge ourself and others and how *they* judge us—which may or may not be the real truth) and ultimate reality or Ma'at (the wisdom of the heart). It is this wisdom that negates all karma (the forty-two assessors!). The Egyptians believed the heart was composed of two aspects: the **hati** and the **ab**. The hati represented the karmic, instinctive, animal or "lower self" equated with the duat on a cosmic level, the dark and sometimes treacherous aspect of the nether realms. The ab symbolized the will, wisdom, and spiritual or "higher self" equated with heaven on a cosmic level, or Love. The union of these two aspects of "self," therefore, resulted in the "mystic marriage" of heaven and

[3] Alan W. Shorter, *The Egyptian Gods: A Handbook* (San Bernardino, Calif.: The Borgo Press, 1994), 55.

earth, ultimate reality, or Ma'at. **Figs. 27–36** depict neteroo commonly associated with protecting and assisting the initiate or the deceased through the Double Hall of Ma'at.

Historically, the netert **Neith** (pronounced and alternately spelled **Net, Nit**) is one of the oldest goddesses, dating back to pre-dynastic Egypt. She acquired the titles *Great Goddess, Opener of the Ways, Lady of the West, Mother of the Neteroo, Ra-t* (the female sun) and was sometimes considered the personification of **Nun,** that which existed before creation.[4] As a netert of protection, she was often depicted with **Nephthys** standing at the head of the deceased's coffin or guarding one of the four **canopic jars** containing the deceased's vital organs. Perhaps one of the most beautiful representations of her is as one of the four golden tutelary statuettes with palms raised protecting the **sarcophagus** of the young **Pharaoh Tutankhamon,** presently housed in the Cairo Museum. In **Fig. 27,** she is shown wearing her traditional headdress, described as a shield and crossed arrows, symbolic of her role in defending the initiate or the deceased against harm, *and* as a weaving

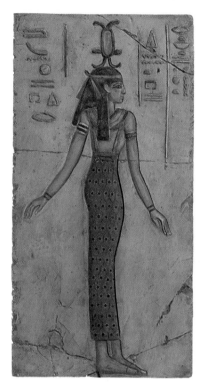

Fig. 27, The Goddess Neith, Wearing Shield and Crossed-Arrows Headdress

Placing "The Goddess Neith, Wearing Shield and Crossed-Arrows Headdress" in your home or office offers creativity, strength, determination, protection against adversity, resolution of conflict and the successful integration of all things—universal Oneness. As one of the four tutelary goddesses, she assists in matters relating to the stomach.

[4] Ions, *Egyptian Mythology,* 101–102.

shuttle, symbolic of the knitted or woven fabric of the universe (notice the similarity in the pronunciation of the words knit and Nit).

Passages in the *Book of Coming Forth by Day* describe elaborate magical spells to avoid being captured in the nets of evil beings during transit through the duat, complete with pictures of the magical nets and the magical names of every part of the nets.[5] As the mother of creation (sometimes called the "first birth giver"), Neith acted as the "great net"—the universe itself—and with magical prowess protected the deceased or initiate against the evil "nets" or entrapments of displaced spirits and negative forces. During the great debate between **Set** and **Horus** as to who should rule Egypt (symbolizing "evil" and "good" respectively), Neith was called upon by the other neteroo to arbitrate. She ruled that the throne should be awarded to Horus, and Set should receive compensation in the form of twice his existing property plus two more wives.[6]

The Greeks' name for Neith was Athene, and they believed her to be one of only two self-created deities who was simultaneously male and female.[7]

It was not uncommon for the roles of neteroo to overlap and be revised and reinvented. For instance, Neith, **Nut**, Mut, **Isis, Hathor,** and **Taueret** were all considered the Divine Mother during various dynasties depending on the political climate and favor of the local priests. In addition, neteroo might be depicted in different guises to indicate the specific role or message being presented. For example, the

[5] Mercatante, *Who's Who in Egyptian Mythology,* 107.
[6] *Ibid, pg. 73.*
[7] E.A. Wallis Budge, *The Gods of the Egyptians or Studies in Egyptian Mythology, Volume I* (New York: Dover Publications, Inc., 1969), 461.

falcon-headed Horus, best known in his role as protectorate of the pharaoh, was known variously as **Horus the Elder;** Heru-p-khart (Horus the Child); **Ra-Harakhte** (Horus of the Two Horizons); Horus-Aah (a composite of Horus and the neter of the moon, Aah); Horus-Bedhdety (meaning Horus of Behdet, a district of the ancient city Edfu); Horus the Hebenuite (portrayed as a hawk-headed man on the back of an antelope symbolizing victory over evil); Horus Khenty en Maatyu (Horus when he was temporarily blinded by his adversary Set); Horus Netcher Nedje Itep (Horus in the role of avenging the murder of his father Osiris), among others. This was true not only of Horus but of all the neteroo.

Horus of the Two Horizons, Ra-Harakhte, is depicted in **Fig. 28** seated with Hathor on royal thrones. Some myths portray Hathor's husband as Ra and others Horus. The discrepancy may have to do with the roles in which they're presented. When portrayed as the "goddess of personal love," it may be more fitting that she be married to Horus, who symbolizes the flesh and blood or actual body of the pharaoh (either the literal pharaoh or the initiate who has conquered and established "rulership" of his or her own faculties). When married to the sun god Ra, however, the emphasis is mystical and symbolizes the marriage between heaven and earth. In this scene, Hathor wears the headdress of the west with solar falcon and feather symbolizing death and resurrection. Although the emphasis is still one of love, the headdress tells us that the nature of the love is impersonal and reflects a more cosmic or heavenly aspect. In other words, Hathor generates unconditional love that imbues the mortal being with the necessary energetic

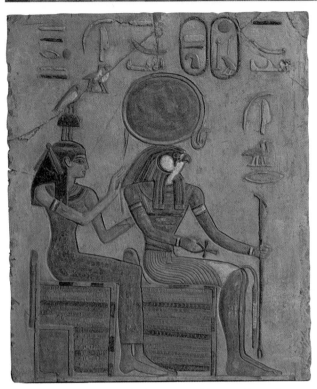

Fig. 28, Falcon-Headed Ra-Harakhte and Hathor

Placing "Falcon-Headed Ra-Harakhte and Hathor" in your home or office generates unconditional love, spiritual and emotional nourishment, transformation and regeneration, and the ability to "rise above" obstacles.

resources for resurrection. In this capacity, she was referred to as the *Cow Goddess of the Duat* and the *Heavenly Cow* as it was she who supplied nourishment to the deceased or initiate. Funerary texts give assurance to the deceased with words such as " . . . the perfect West: her arms will receive you."[8]

Another one of Hathor's many titles is *Eye of Ra,* associated with the star Sothis (thought to be the star we call Sirius). The Egyptians believed that upon attaining self-mastery, a being became a radiant, shining star. This may be an allegory to the halo of **qi** emitted by self-actualized masters such as Buddha, Jesus, the Virgin Mary and others, portrayed in various classical paintings.

Whereas the neter Horus symbolized the pharaoh, the netert Hathor symbolized the queen. Ascension (or self-mastery) was therefore seen

[8] Richard H. Wilkinson, *Reading Egyptian Art, A Hieroglyphic Guide to Ancient Egyptian Painting and Sculpture* (London, England: Thames & Hudson, 1994), 167.

as a potential for *both* men and women. Each possessed the possibility to radiate perfected awareness symbolically reflected in the imagery of a bright star or "living sun"—in other words, the living "sun" (radiance, illumination) as well as the living "son" (child) of god.

Fig. 29 shows Nephthys and her sister Isis ritually preparing the sun god Ra as he passes through the duat. Ra is portrayed in **mummiform** with the head of the Ovis ram crowned with the solar disk symbolizing the form or embodiment of death which the sun-god assumes during his nightly journey and sheds with the dawn of day.[9] Like the **Apis** bull, the Ovis ram was equated with virility and regeneration, suggesting the rising sun or resurrection of the deceased.

The most common myths

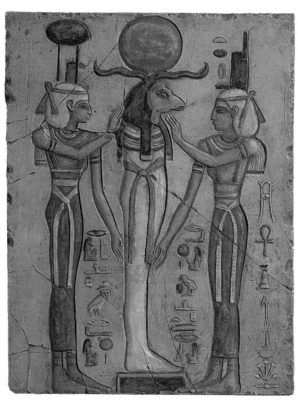

Fig. 29, Nephthys and Isis Prepare Ra in Mummiform

Placing "Nephthys and Isis Prepare Ra in Mummiform" in your home or office establishes balance between the forces of yin and yang. This fosters cooperation and assistance, victory over negativity, forgiveness, completion of projects, and release of outmoded aspects of self so that generation and renewal may occur. As tutelary goddesses, Isis assists in matters relating to the liver, while Nephthys assists with the lungs.

[9] Shorter, *The Egyptian Gods: A Handbook,* 89.

of Nephthys refer to her as the wife of the evil neter Set; therefore, we must assume by association that Nephthys also has an evil or dark tendency since she is "married" (united or one) with him. This bears out as she is said to have sexually seduced **Osiris,** Isis's husband, through deceitful means or trickery. Although barren while married to Set, Nephthys's union with Osiris produced the child **Anubis.** Set's discovery of the infidelity further fueled his jealousy towards his brother Osiris and added impetus to the plot to murder him. Fearful that Set would take revenge on the child, Nephthys abandoned her husband and awarded the care of the child to Isis who, with unconditional compassion, raised the child as her own. Some myths portray Nephthys assisting Isis in collecting and reconstituting her husband's body after Set chopped it into pieces whereas others suggest that Anubis performed the mummification rites. Regardless, there is a great deal of symbolism in the stories suggesting that although Nephthys behaved badly, she was also attracted to goodness, i.e., Osiris. Furthermore, she was barren when married to Set (evil) but fertile when attracted to Osiris (goodness). Isis, the Divine Mother, accepts both Nephthys and her child Anubis with unconditional love. The moral of the story is that Nephthys abandons evil and is attracted to goodness, and the resulting birth (symbolic of her own renewal) provides the tools for resurrection or ascension. Throughout it all, Isis, the Divine Mother, accepts Nephthys, the illegitimate child and her unfaithful husband with unconditional love. This runs parallel to the negative confession of the deceased or initiate in the Hall of Ma'at who, by the rejection and negation of harmful thoughts, words and deeds, and recognition of ultimate

Truth, Ma'at (wisdom of the heart) invokes liberation of the soul.

The duat was filled with all sorts of monstrous spirits and treacherous pitfalls that the deceased or initiate might fall prey to. Magical knowledge, spells and prayers were believed to protect and ward off such dangers as well as transform the deceased or initiate into the company of neteroo. **Fig. 30** portrays the lovely **Nefertari,** favorite wife of **Ramses II,** asking Thoth, the ibis-headed neter of wisdom, for his bowl and scribe's pallet in order to obtain the highly sought-after magical formulae. Nefertari's left hand (the hand of receiving) is placed upon a stand containing Thoth's pallet and bowl with a frog perched on the bowl's rim. The frog symbolizes creation—life that is generated from water or the cosmic sea of **Nun.** In late dynastic Egypt the frog **hieroglyph** was used to express *wekhem ankh* meaning "repeating life" and was subsequently adopted by Christianity as a symbol for resurrection.[10] This particular scene is an artistic rendition of Spell 94 of *The Book of Coming Forth by Day* that appears in Nefertari's tomb.

Many people today believe Thoth authored a set of sacred "books" known as *The Emerald Tablets* written in a language of light upon indestructible emerald tablets that consist of all knowledge on every topic, both human and divine. Most respected archaeologists tend to dispute this idea due to a lack of archaeological evidence. Although spectacular in theory, we presently have the technology to store information written by laser (or light) within crystalline substance, so that which seemed impossible twenty-five years ago may be considered only incredulous today. Edgar Cayce, known as "the sleeping prophet," predicted that this "hall of records" would be discovered and opened in 1998 in a

[10] Wilkinson, *Reading Egyptian Art: A Hieroglyphic Guide to Ancient Egyptian Painting and Sculpture,* 107.

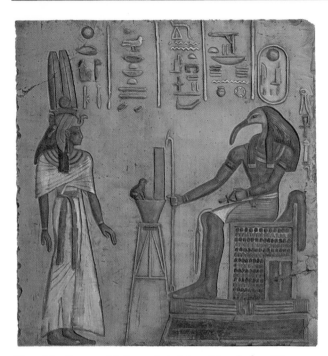

Fig. 30, Queen Nefertari Asking Thoth for His Magical Powers

Placing "Queen Nefertari Asking Thoth for His Magical Powers" in your home or office invokes knowledge of all the arts and sciences, power over the elements such as weather and time, wisdom of the heart, truth and integrity, and the ability to ask for that which is needed with the trust it will be provided.

secret chamber housed beneath the right paw of the Sphinx. Although underground tunnels and cavities have, in fact, been found near and around the right paw of the Sphinx, to date no disclosure of a "hall of records" nor the Emerald Tablets has been reported.

The ancient Greeks credited Thoth with writing forty-two sacred books they referred to as the *Books of Thoth* that covered topics such as the neteroo, religious practices, the law, history, geography, hieroglyphics, astronomy, astrology and medicine. The Egyptologist Brugsch believed he discovered the hieroglyphic titles of many of these books on the temple walls of Edfu.[11] However, the authorship of even the most ancient texts is in dispute, some saying Thoth wrote the *Book of Coming Forth by Day* and the **Book of Breathings** (a simplified and greatly reduced translation of the

[11] Wilkinson, *Reading Egyptian Art: A Hieroglyphic Guide to Ancient Egyptian Painting and Sculpture,* 414.

former attributed to the Eighteenth Dynasty), while others say he did not. Historical evidence to the contrary, the true metaphysician knows that Thoth, the heart and tongue of Ra, has many hands and many faithful scribes past, present and future, and that the *Books of Thoth* are written in form and in formlessness. The following is excerpted from the *Book of Breathings* and extols the benefits of obtaining the secret formulae of Thoth:

> *Thoth, the most mighty god, the lord of Khemennu, cometh to thee, and he writeth for thee the* Book of Breathings *with his own fingers. Thus thy soul shall breathe for ever and ever, and thy form shall be endowed with life upon earth, and thou shalt be made a god along with the souls of the gods, and thy shall be the heart of Ra, and thy members shall be the members of the great god.*[12]

Thoth was often accompanied by his good friend Anubis, the illegitimate child of Nephthys and Osiris conceived through Nephthys' trickery. Anubis appeared as a dog-headed or jackal-headed man. As such, he demonstrates many of the positive traits of a dog: companionship, loyalty, protection, assistance in guiding the "blind" (i.e., the "blind" initiate or deceased who is unable to see his/her way through the pitfalls of the duat). Stray dogs often congregated at burial sites of the dead and it may be for this reason that Anubis was associated with the dead. Some myths indicate Anubis played a role in assisting Isis in wrapping the dismembered pieces of her husband's body in linen after being slain by Set. Thus the first mummification was performed, and

[12] Wallis Budge, *The Gods of the Egyptians, Volume 1*, 409.

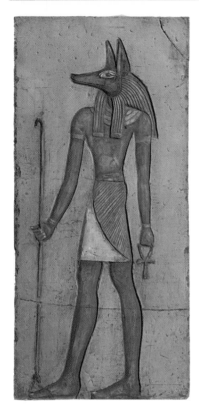

Fig. 31, Jackal-Headed Anubis, Guide of the Dead

Placing "Jackal-Headed Anubis, Guide of the Dead" in your home or office establishes companionship, loyalty, guidance, protection, enhanced visionary attributes, and a bridge between the deceased and the living, other realms and the Earth.

together with the recitation of the magical spells of Thoth, the body was restored to eternal life. Anubis was said to guard the entry of the Double Hall of Truth and is frequently portrayed assisting in the weighing of the heart. He's shown in **Fig. 31** with **uas** scepter (scepter of the neteroo in his right hand) and **ankh** (symbol of life) in his left hand.

Another netert associated with the dead was **Selket** (also known as Serquet). She is most commonly portrayed at the foot of the sarcophagus with Isis, while Nephthys and Neith stand guard at the head. She was represented as a woman wearing a scorpion headdress or with the head of a scorpion. She is beautifully represented as one of the four golden statuettes guarding Tutankhamon's sarcophagus on display in the Cairo museum. It was Selket who kept the evil snake Apep at bay in the underworld so that Ra could make safe passage and rise in the morning. She was also thought to protect against a dangerous curve in the duat and bind evil beings with chains as well as use her vast knowledge of magic to protect the deceased or the initiate. She was said to have sent seven scorpions to protect Isis against Set and was able to heal poisonous

bites and toxins. Her name means "she who causes the throat to breathe" and is therefore associated with life. She is sometimes portrayed in the role of nursemaid to Isis's young son Horus, symbolizing her role as a protector of children as well as the pharaoh, since the pharaoh was considered the embodiment of Horus.

Although the Egyptians have been accused of being preoccupied with death, it might be more accurate to say they were fixated on life. Death was perceived as nothing more than a transitory state similar to sleep. Just as we retire each evening, close our eyes and awaken with the morning sun, death was perceived in a similar fashion. The soul was believed to have continuity from this realm into the next and, if properly prepared, to have the ability to manifest in either the heavenly or earthly realms in a variety of embodiments like the neteroo themselves. Therefore, the most important symbols to the Egyptians were those that depicted life.

The **Belt of Isis** or **tiet** in **Fig. 33A** is similar both in appearance and symbolism to the ankh. Although both refer to "life," the ankh incorporates both male and female properties whereas the Belt of Isis is purely a feminine symbol. On an

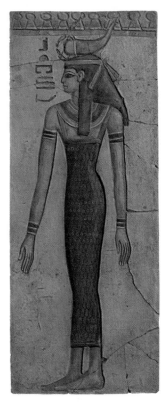

Fig. 32, Selket Wearing Scorpion Headdress

Placing "Selket Wearing Scorpion Headdress" in your home or office transmutes the "poisons of the mind" such as anger, envy, greed, laziness and fear and may be helpful in overcoming emotional and physical dependencies such as substance abuse. In addition, it may serve in a "guardian angel" capacity to protect children as well as all others against negative influences.

Fig. 33A, Belt of Isis

Placing the "Belt of Isis" in your home or office honors the feminine principal and promotes sexual attraction, fertility, regeneration, creativity, beauty and receptivity. It may be beneficial in regulating hormonal balance and enhancing intuition.

initial level, it represents the knot or girdle that was tied around the waists of the neteroo (both male and female) to secure their garments. On a deeper level, the tiet is symbolic of and shaped like the female reproductive organ. In this capacity, it is sometimes called the *Blood of Isis*. It was said that when Isis learned of the dismemberment of her husband Osiris by Set, she cried tears of blood. Through the use of magical means, she formed the tears into an amulet made of red carnelian to assist in the resurrection of her husband. The blood, therefore, had a generative aspect to it. Whereas the tiet is shaped like the female reproductive organ and generally red in color, it may symbolize the blood that is shed on a monthly basis indicative of a woman's capacity to produce life. Tiet amulets made of crystalline substances such as jasper, jade, carnelian and red glass were prepared as funerary talismans by the Egyptians purportedly to ensure life after death. Even today, some religions conduct sacred rites in which wine is offered in communion, symbolic of the blood of the Divine. As blood is crystalline in nature, it can coherently store information (such as DNA) that can be easily accessed and transferred from one medium to another. According to the late Dr. Marcel Vogel, a long-time research scientist at IBM and one of its most prolific inventors, the breath may be used to create a

magnetic charge that releases information stored in crystalline substances, either solid or liquid.[13] Like the ankh, the Belt of Isis has association with yogic breath exercises. Specifically, the breath is directed in a horizontal or "beltlike" fashion from the umbilical point of the body. The implications associated with these teachings are enormous and of a deep and profound mystical nature.

Whereas the *tiet* or Belt of Isis symbolized the physical path or means of birth/rebirth, the neter **Nefertum** symbolized the precious fluidic and etheric essences associated with birth/rebirth. Nefertum was often depicted as a boy emerging into life from the center of a **lotus** bloom or sometimes as a full-grown man wearing a lotus flower headdress. He is portrayed in **Fig. 33** with Pharaoh **Ramses I** who offers Nefertum two globular vessels. Wine, milk or water was usually offered in these types of containers. Nefertum means "lotus" and he was known as the *Lord of Perfumes*[14] and *Watcher at the Nostrils of Ra*.[15] The latter title identifies Nefertum with breath, which the Egyptians strongly equated with life both on a functional as well as a metaphysical basis. As in ancient Egypt, the lotus is depicted since ancient times in Hindu and Buddhist traditions to symbolize the intersecting meridians in which qi accumulates and is distributed throughout the body, resulting in life. Known as **chakras,** these spinning wheels of light are artistically represented as lotus flowers at strategic points of the body. This seems to bear out in the Egyptian tradition as well, as the hieroglyph for "nefer" is that of the heart and trachea and was frequently inscribed on amulets to ensure youthfulness, beauty, happiness and good fortune.

[13] *http://www.vogelcrystals.com/legacymarcel.htm*
[14] Wilkinson, *Reading Egyptian Art: A Hieroglyphic Guide to Understanding Egyptian Painting and Sculpture,* 121.
[15] Ions, *Egyptian Mythology,* 104.

The roots of the lotus flower descend into the mud or earth, the stem grows in water and the bloom emerges into atmosphere or air. At night the flower closes into a tight bud that opens the following morning. Therefore, the lotus was seen to be triune in nature and pass through various cycles of "death" and "rebirth." The flower was displayed in an upright position and usually in water when referencing the mystical aspects of it; however, when purely ornamental, the flower was drawn with a bent stalk and a drooping bloom.

The masculine symbol of the **djed,** a pillar-shaped object associated with Osiris, was usually shown in close proximity to the feminine symbol of the tiet, the Belt of Isis. It mythically represents the tree that the sarcophagus containing the body of Osiris became embedded in. After Set murdered Osiris by tricking him into the coffin and nailing it shut, he threw the coffin into the Nile River where it floated downstream and became entombed in a Tamarisk tree. Due to its beauty, the King of Byblos cut the tree down and made it into a pillar in the royal palace. Isis subsequently retrieved the pillar, exhumed the body of her husband and subsequently performed magical ritual to effect resurrection. Thus the djed pillar is associated with stability, potency, virility, resurrection and the Tree of Life itself. Like the tiet, whose shape simulates the female reproductive organ, the djed is correlated with the male reproductive organ. It symbolizes the masculine generative potential both physically and etherically. It also corresponds to the backbone or spine of the body as the vertical pathway that qi follows as it courses throughout the chakra points of the body.

The djed of Osiris is shown in **Fig.** 33C with a basket resting upon it containing the cobra goddess **Wadjet,** protector of the pharaoh. An ornament in the shape of a raised cobra called a **uraeus** was attached to the diadem worn on the forehead of the pharaoh. On a first-level basis, this was due to the belief that the cobra would

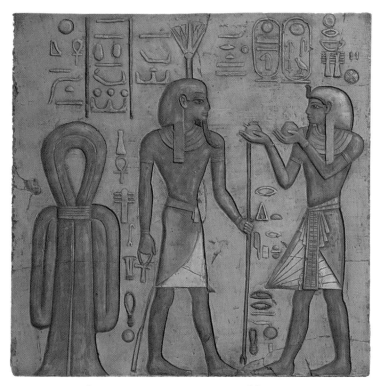

Fig. 33B, Nefertum Wearing Lotus Headdress

Placing "Nefertum Wearing Lotus Headdress" in your home or office facilitates renewal, birth and rebirth, unification of the triune aspects of self (body, mind and spirit); activation of the energy vortexes of the body, enhancing health, youthfulness, happiness, awareness, well-being and good fortune.

protect the pharaoh by spitting in the eyes of the pharaoh's enemies. On a second level, the uraeus was worn as a cult symbol representing the heightened awareness of the king. The pharaoh was required to remain active in the priesthood as the official intermediary between the neteroo, the priesthood and the people. In fact, he was considered the

eyes, ears, tongue and heart of the neteroo. As the pharaoh cultivated and activated qi in his body through breath work and meditative exercise, the qi rose up the spine like a standing cobra, endowing the pharaoh with intuitive insight. Therefore the uraeus was worn on the forehead of the pharaoh, symbolizing the opened "third eye." Cobras were often used to guard sacred sites and tombs by the priest-magicians. *The Book of That Which Is in the Duat* and the *Book of Gates* specifically make reference to these creatures guarding the gates of each hour in the duat. Baskets were often used to carry the cobra and had various meanings including "master" and "all." Therefore, the combination of the djed, basket and cobra indicates "all life, potency and protection to the pharaoh or master."

The netert Wadjet was sometimes represented as a woman wearing the red crown of lower Egypt, but more commonly she was depicted as a cobra wearing the red crown or sometimes the double crown that united lower and upper Egypt. Her counterpart is **Nekhebet,** the vulture goddess, who symbolized upper Egypt. The pharaoh frequently wore double uraeus consisting of both cobra and vulture, symbolizing unification between the two lands as well as "lower" and "higher" self.

Each person faces challenge and obstacles in life

Fig. 33C, Djed of Osiris with Cobra Goddess Wadjet in Basket

Placing "Djed of Osiris with Cobra Goddess Wadjet in Basket" in your home or office honors the masculine principle, and evokes stability, virility, potency, renewal and endurance. It is protective and helps one establish self-control and effective leadership.

that must be met and conquered. Likewise, the pharaoh was seen as the all-powerful and compassionate hero who was capable of defeating the enemies of the Egyptian people and looking out for their welfare and best interests. He was therefore equated with Horus, the son of Osiris and Isis, who avenged the death of his father by conquering the evil Set. Horus is viewed as the epitome of goodness whereas Set is the antithesis, evil itself, or at the very least entropy, the natural decline and decay of matter. Usually represented as a man with a hawk's head, **Fig. 34** is unique in that it shows Horus in totally human form. This symbolizes that each of us has the potential to become Horus, or one who conquers all self-defeating thoughts and actions—and ultimately death itself. In this particular scene, Horus is shown wearing a leopard skin associated with the priesthood. In many traditions, one who has achieved enlightenment is often portrayed seated on the fur of a leopard or jaguar or seated on top of the animal, symbolizing victory over "animal instincts" or the lower nature of self. The scene is from the colorful tomb of Queen Nefertari, one of the loveliest sites in all of Egypt (and presently open to the public). In its original setting, this scene depicts Horus with his right hand extended towards his father, Osiris, as if to "show the way" to the deceased or initiate. In other words, Horus is directing the ordinary man or woman on how to achieve resurrection or eternal life by re-membering (a pun on the dis-memberment of Osiris) one's own inherent goodness.

Physical matter is polarized or dualistic by nature. At one end of the spectrum is life; at the other is death. The two go hand in hand. In this context, the neteroo of creation often simultaneously share roles in

funerary capacities. The neter **Ptah (Fig. 35)** is a perfect example. Generally represented as a man in mummiform (the linen wrappings used to preserve a corpse), he was regarded in the cult city of Memphis as the Divine architect of the universe. It was said that everything came into being through the heart and tongue of Ptah, including all neteroo, all people, all cattle and all creeping things. He was known as the *Great Artificer* and was especially revered by craftsmen, artists, masons and architects. He was often portrayed wearing a close-fitting skullcap and false beard and holding a scepter that combined the elements of the ankh, uas and djed, symbolizing life, power and endurance, respectively. His skin was green, the color of vegetation, growth and renewal, and he was also associated with the Apis bull, a symbol of virility.

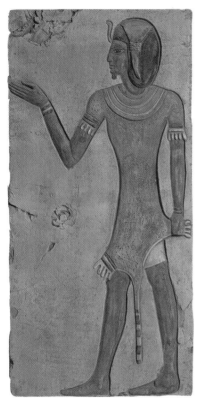

Fig. 34, Horus the Savior Wearing Leopard Skin

Placing "Horus the Savior Wearing Leopard Skin" in your home or office evokes victory over negativity, strengthens moral integrity, promotes effective leadership of others, helps eliminate self-defeating thoughts and actions, and promotes visionary acuity, wealth, power and self-mastery.

The diversity of creation myths and "creator gods" may seem contradictory and confusing at first glance; however, each story represents a different aspect of creation. For example, the neter Ptah symbolizes the *spiritual* formation of matter through the heart (love) and tongue (word) of the Divine (logos), i.e., "In the beginning was the Word," whereas the neter

Atum and his associated creation myth represents the *scientific* principals of the formation of matter— the atom. Each gives a unique perspective on how matter was created.

The Word of the Divine has been translated into many languages and is the basis of worldwide spiritual traditions. The Tao Te Ching, the Vedas and Upanishads, the Pali Canon, the Torah and the Talmud, the Koran, and the Bible are all considered sacred, holy writings. Ancient Egyptian texts written in hieroglyphics and referred to as "holy books" (such as the *Book of Coming Forth by Day*, the *Book of Breathings*, the *Book of Gates*, the *Book of That Which Is in the Duat*, and many others) are some of the oldest known writings in the world. The word "hieroglyph" is Greek in origin and means "sacred carvings" or "holy writings." Until recently, it was believed that the Sumarians or inhabitants of ancient Mesopotamia (present-day Iraq) were the first to invent writing. According to ancient Egyptian mythology, it was Thoth, the neter of wisdom, who invented writing. In 1998, the earliest known writings (carbon dated to 3300 to 3200 B.C.) were discovered in southern Egypt on ivory labels attached to bags

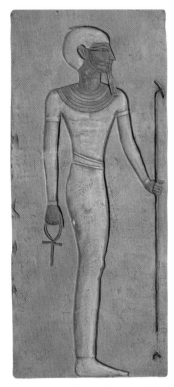

Fig. 35, Ptah, Architect of the Universe, in Mummiform

Placing "Ptah, Architect of the Universe, in Mummiform" in your home or office promotes fatherly love, creativity, regeneration, virility, endurance, powerful speech, adaptation to cyclical patterns, success in the creative and building arts, and enhanced ability to plan and manifest goals.

of linen and oil in the tomb of King Scorpion I recording the origin of the funerary items.[16, 17]

A passage of Hermetic literature from the *Virgin of the World* ("Hermetic" referring to "Hermes," the Greek name for Thoth and the "Virgin" referring to Isis) states,

> *The sacred symbols of the cosmic elements were hid away hard by the secrets of Osiris. Hermes, ere he returned to Heaven, invoked a spell on them, and spake these words:* **'O holy books,** *who have been made by my immortal hands, by incorruption's magic spells . . .* [text is illegible] *. . . remain free from decay throughout eternity, remain incorrupt from time! Become unseeable, unfindable, for every one whose foot shall tread the plains of this land, until old Heaven doth bring forth meet instruments for you, whom the Creator shall call souls.' Thus spake he; and, laying spells on them by means of his own works, he shut them safe away in their own zones. And long enough the time has been since they were hid away.*

Thoth was said to be self-begotten, first appearing on a lotus flower through the power of utterance, or the Word. As such he is considered Divine Intelligence or Divine Thought. He's also purported to be the heart and tongue of Ra. Although there is great disagreement as to the correct pronunciation of his name (which is the Greek derivative), several pronunciations seem to be popular: Thōth with a long "o" is quite common as well as Tōth and Tawth. Perhaps the most logical is Thot (as in "thought") or Taut (as in "taught"). His Egyptian name is Djehuty,

[16] *BBC News,* Tuesday, December 15, 1998, *http://news.bbc.co.uk/hi/english/sci/tech/newsid_235000/235724.stm.*
[17] *Microsoft Encarta Encyclopedia 1999,* "Archaeology: Alphabet Originated Earlier Than Previously Believed."

pronounced Tahuti. Not coincidentally, the syllable "hu" is associated with sound in many languages.

In addition to inventing language and writing, the sciences and arts, medicine, magic, mathematics, astronomy, astrology, and so on, Thoth was known as the *Measurer of Time* and the *Keeper and Recorder of All Knowledge*. It is he who records the results of the final judgment of the deceased or initiate during the weighing of the heart ritual in the Hall of Ma'at.

He's usually portrayed as an ibis-headed scribe with pallette and reed pen in hand. The exact symbolism

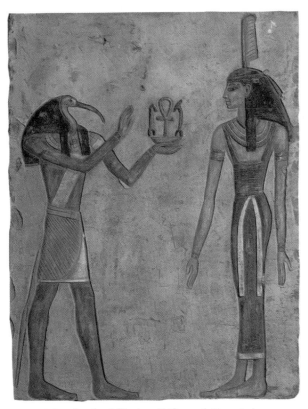

Fig. 36, Thoth Offering Life and Dominion to Ma'at

Placing "Thoth Offering Life and Dominion to Ma'at" in your home or office evokes integrity, honesty, wisdom, power, balance and order, longevity, unity, successful completion, enlightenment, and awareness of ultimate Reality.

of the ibis is obscure. Speculation ranges from the theory that ibis were known to eat snakes and were prevalent at Hermopolis, the chief cult center of Thoth. One fascinating hypothesis is that the human brain stem and lobes resemble an ibis when its head and neck are tucked. In

the capacity of *Measurer of Time,* Thoth is usually represented with a notched palm reed in hand and wearing the lunar disk as the moon reflects cycles of time. He also wears the lunar disk in association with magic since the moon symbolizes the hidden elements. At times Thoth is also portrayed as a dog-faced baboon of the genus *Cynocephalis,* who were observed to howl and raise their arms in salute to the sun at dawn.

In **Fig. 36,** Thoth is shown offering the symbols of life and domin-ion to his wife, Ma'at, representing the power and eternal nature of ultimate reality or Truth.

5

THE STARRY DUAT

The Egyptians poetically conceptualized the sun's passage from horizon to horizon as **Ra** (the sun) sailing through the body of **Nut** (the sky) in the **Barque of Millions of Years.** As the sun descended in the evening, it was believed to enter into the **duat**, a dark tunnel-like passageway often mistakenly associated with the underworld or hell realms. In fact, the Egyptian **hieroglyph** for duat is a star within a circle and early renditions of the *Book of Coming Forth by Day* describe the duat to be circular in nature, the abode of **Osiris** and near the heavens. Both beneficent and treacherous beings were believed to inhabit the duat. A painted representation of the duat on the sarcophagus of **Seti I** depicts Osiris bent with his toes touching the back of his

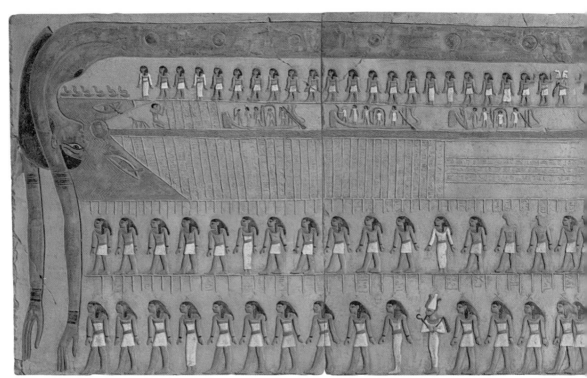

Fig. 37, "Barque of Millions of Years As It Sails the Starry Duat"

Placing "Barque of Millions of Years As It Sails the Starry Duat" in your home or office evokes inner vision, forward momentum, successful navigation and passage through times of challenge, the opening of new doors, the unveiling of mystical sciences, Divine guidance and self-mastery.

head, similar to the Greek *uroboros*, the cosmological symbol of a snake swallowing its tail.

The duat was believed to consist of twelve divisions that correspond with the twelve hours of the night and contained a multitude of gates and gatekeepers whose secret names must be known in order for passage through one division to the next. A river ran through the valley of

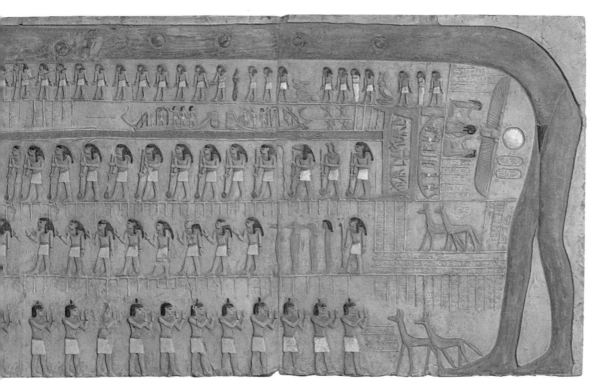

the duat corresponding to the Nile River on earth and the Milky Way in the heavens. Good and evil beings wishing to board the Barque of Millions of Years or thwart its passage congregated on the two banks of the river. The successful navigation through this dark and sometimes treacherous passageway resulted in the sun's rising and subsequent illumination or "coming forth by day."

On a larger scale, Ra sailing through the duat into the heavens is a map of the cosmos and signifies the process that unfolds as the deceased passes through realms of consciousness in the journey to "heaven." It also reflects a map of the physical human body and a

process that may be undertaken *while living* that results in illumination or "heavenly" bliss. The macrocosm and microcosm are identically ordered, or, in the wise words of **Thoth,** the Egyptian **neter** of wisdom, "As above, so below."

According to yogic science, three channels run through the center of the human body aligned with the spine. The center or main channel (equivalent to the Nile River and/or the Milky Way) is called the Shushuma and is considered neutral. The Pingala and Ida (equivalent to the two banks where "good" and "evil" beings await) run parallel to the Shushuma and are considered negative and positive in orientation. Breath is moved through specific vortexes called **chakras** (symbolic of the "gates") in a circular orbit. When unification of body, mind and spirit has been achieved, a state of illumination and radiance occurs on both physical and non-physical levels. The number of major chakras within the body varies from tradition to tradition. Some suggest there are seven chakras while others believe there are eight. Yet others believe there are twelve, and some traditions number them in the hundreds. Egyptian texts differ in their description of the number, locations and secret names of these "gates."

Fig. 37 depicts the elongated body of the sky goddess Nut stretched from horizon to horizon as the barque of Ra makes its passage through the duat.

The ancient Egyptians' fascination with the stars is repeatedly demonstrated through precise architectural design, orientation and art such as the famous circular zodiac of Dendera. Dating to the second century B.C., the original zodiac is now housed in the Louvre in Paris

while a replica adorns the ceiling of one of two shrines dedicated to the neter Osiris. The stars, planets, and symbols of the zodiac are represented within the center, and bands on either side show the course of the sun and the moon. The twelve signs of the Egyptian zodiac and their corresponding symbols are not too different from the traditional signs used today:

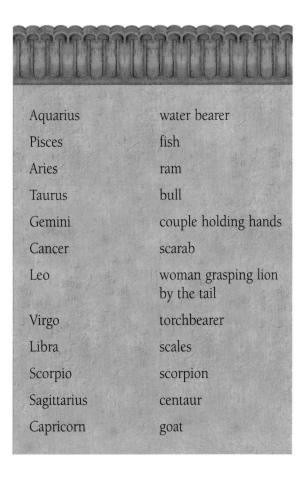

Aquarius	water bearer
Pisces	fish
Aries	ram
Taurus	bull
Gemini	couple holding hands
Cancer	scarab
Leo	woman grasping lion by the tail
Virgo	torchbearer
Libra	scales
Scorpio	scorpion
Sagittarius	centaur
Capricorn	goat

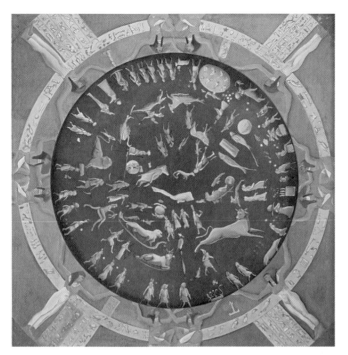

Fig. 38, Zodiac of Dendera

Originally adorning the ceiling of a shrine dedicated to Osiris in the Temple of Dendera, this famous zodiac is presently housed in the Louvre in Paris, France. It facilitates awareness and appreciation of cosmic forces and their cyclical influence upon us and promotes the tools to regulate and master time, and the integration of macrocosmic and microcosmic principles.

6
COMING FORTH BY DAY

Knowing what to expect and how to counteract fear, obstacles and challenges during death and initiation were indispensable to the beliefs of the ancient Egyptians. Prayers, hymns, protective formulae and detailed instructions were written in early dynastic Egypt to facilitate the safe passage of the royal family and the privileged sector through the **duat** and into the heavenly realms. After only a few centuries, the general public was permitted to buy generic versions of the texts and insert the name of the deceased into a blank space. Scrolls such as the ***Book of Coming Forth by Day*** or the shorter version called the ***Book of Breathings,*** the ***Book of Gates,*** the ***Book of That Which Is in the Duat*** or other sacred texts were

placed with the mummy as well as copied onto sarcophagi and tomb walls.

The passage of time has taken its toll on **papyri**, leaving many of the texts fragmented and illegible. The copies themselves vary from version to version, partly due to scribe error but mostly as a result of changes in the sociopolitical era in which the documents were written. One of the finest scrolls excavated to date is that of the **papyrus** of the scribe Ani dating to 1250 B.C. It is seventy-eight feet in length, beautifully illustrated, and presently housed in the British Museum.[1]

Fig. 39 is from the funerary papyrus of Nakht, a royal scribe and chief military officer of the Eighteenth Dynasty. The scene is associated with Spell 99 in the *Book of Coming Forth by Day* and gives instruction for obtaining a boat to cross the celestial Nile. The acquisition of a sailing vessel in the afterlife was considered so important to the ancient Egyptians that boats were often buried in tombs with the dead. In 1954, a perfectly preserved and dismantled "solar barge" 144 feet in length was found in a large pit on the south side of the Great Pyramid. The cedar wood boat has been painstakingly reconstructed with 95 percent original material and is displayed intact in the white museum near the Great Pyramid.

The deceased Nakht calls on the ferryman Mahaf to awaken Aqen, who is in charge of the boat. Mahaf makes excuses and questions Nakht in a kind of game until finally agreeing to arouse Aqen. The awakened Aqen is not very cooperative and informs Nakht that the boat is not fully equipped. Nakht assures Aqen that he is an accomplished magician and has the ability to call forth **neteroo** to properly

[1] *The Egyptian Book of the Dead, The Book of Going Forth by Day,* trans. Dr. Raymond Faulkner, (San Francisco: Chronicle Books, 1994), 11.

equip the boat. Aqen, however, refuses to honor the request until Nakht reveals the secret names of the boat's parts. Nakht does so and successfully acquires the boat. He's shown seated in the small sailing vessel holding two sheets (ropes) to control the sail as it fills with wind.[2]

Spell 99, the acquisition of a boat, is cleverly worded to reveal the esoteric imagery of **kundalini,** the yogic practice of intentionally raising **qi** from the base of the spine where it lies sleeping like a coiled serpent. Nakht calls on Mahef to awaken Aqen, the sleeping qi, but Aqen is initially unresponsive. Aqen taunts Nakht by suggesting the "boat" is not fully equipped. The vessel Aqen refers to is Nakht himself. Nakht responds that he is an "accomplished magician" or yogi. Furthermore, he knows how to call forth neteroo to properly equip the "boat." Nakht is saying here that he knows how to call forth forces that will enable him to have full use of his yogic faculties. Aqen calls his bluff and asks him for the secret names of the boat. Nakht does so and is given the boat. In other words, Nakht knows the secret names or **bija** (sacred sounds or seed syllables such as "om" and "hum" that emanate from the **chakras**) that allow the sacred winds (breath) to flow through his body, thus giving Nakht the means to project his consciousness into the heavenly realms.

There is a postscript at the end of Spell 99 that reads:

As for him who knows this spell, he will go out into the Field of Rushes, and there will be given to him a cake, a jug of beer and a loaf from upon the altar of the Great God, an oroura of land with barley and emmer by

[2] *The Ancient Egyptian Book of the Dead,* 90–97.

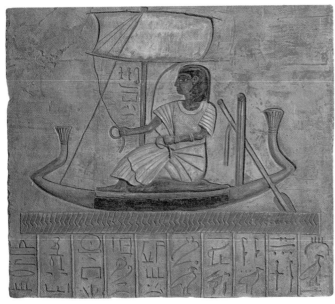

the Followers of Horus, who will reap them for him. He will consume this barley and emmer and will rub his body with them, his body will be like these gods, and he will go out into the Field of Rushes in any shape in which he desires to go out. A matter a million times true.[3]

Thoth, the ibis-headed **neter** of wisdom, is shown in **Fig. 40** opening the gates of the four cardinal directions. Associated with Spell 161 of the *Book of Coming Forth by Day,* the accompanying text reads like a Zen koan or riddle:

Fig. 39, Nakht Sailing the Celestial Nile

Placing "Nakht Sailing the Celestial Nile" in your home or office evokes safe passage into unknown realms, control over the elements, forward momentum, the acquisition of mystical knowledge, cooperation from others, self-mastery and heavenly bliss.

Ra lives, the tortoise is dead, the corpse interred and N(akht's) bones are reunited. Ra lives, the tortoise is dead, and he who is in the sarcophagus and in the coffin is stretched out.[4]

[3] *The Ancient Egyptian Book of the Dead,* 97.
[4] *The Egyptian Book of the Dead, The Book of Going Forth by Day,* 125.

The riddle implies that the corpse is an empty shell, a "dead tortoise," but the soul lives on in the form of **Ra** (the sun or living light) and is "stretched out." The mystical application is even more clearly delineated in a rubric that follows the spell:

Fig. 40, Thoth Opening the Gate of the Four Winds

As for any noble dead for whom this ritual is performed over his coffin, there shall be opened for him four openings in the sky, one for the north wind—that is Osiris; another for the south wind—that is Ra; another for the west wind—that is Isis; another for the east wind—that is Nephthys. As for each one of these winds which is in its opening, its task is to enter into his nose. No outsider knows, for it is a secret which the common folk do not yet know; you shall not perform it over anyone, not your father or your son, except yourself alone. It is truly a secret, which no one of the people should know.[5]

Placing "Thoth Opening the Gate of the Four Winds" in your home or office establishes proper direction, the opening of vital passageways, steady movement, energy, potency, yogic powers, stability, benefit to the lungs, heart and vital organs, longevity, and wisdom.

The rubric starts off by saying, "As for any noble dead for whom this ritual is performed . . ." and paradoxically ends with the admonition "you shall not perform it over anyone . . . except yourself alone." As with many other texts, this

[5] *The Ancient Egyptian Book of the Dead,* 156.

passage has multiple meanings. On a first level, it offers instructions to the deceased for successful passage through the duat and into the heavenly realms, and on a second level, it suggests wisdom (Thoth) must be acquired in order to open the "gates" that allow the four sacred winds or breaths to flow through the nose, thus activating the breath of eternal life (**ankh**).

The deceased scribe Ani is portrayed in **Fig. 41** walking through the "gate" or door of his "tomb" opened by the neter of wisdom, Thoth. Ani's **ba** (soul) hovers above him, represented by a human-headed hawk carrying a **shen**, symbol of eternity. This scene is associated with Spell 92 of the *Book of Coming Forth by Day* and was used to

Fig. 41, Ani and His Hawk-Headed Soul Exit the Tomb

Placing "Ani and His Hawk-Headed Soul Exit the Tomb" in your home or office induces clear awareness of metaphysical realms, freedom of movement, unification of lower and higher selves (body and soul), duration, longevity, and victory over entropy and illness.

magically reactivate the limbs to permit the soul to move freely from one realm to another.

At night, while sleeping, we often engage in dream activity and assume a dream-body, referred to in certain cultures as the astral body. The Egyptians called this body the **ka.** Upon achieving self-mastery or experiencing death, whichever transpires first, it was believed that a similar body is activated called the **ba,** associated with the soul. The ba and ka are respectively linked through the **ab** and **hati** of the heart. The hawk symbolizes freedom of movement in that the soul is no longer hindered by physical constraints such as gravity or entropy. The human constituents are still present, however, as evidenced by the human head.

If applied to the **initiate** (as opposed to the deceased), the opening of the "tomb door" is a metaphor for opening the "gate" as described in the preceding scene (Fig. 39). Failure to successfully open the "gate" results in mortality (symbolized by the tomb) as opposed to immortality (signified by the shen).

Death is inexorably linked with birth; they're two faces of a single coin, like night and day and **yin** and **yang.** As such, neteroo often played dual roles. **Osiris,** primarily associated with death, also symbolized regeneration and resurrection. **Hathor,** the **netert** of love and birth, was also associated with death and the west, the place where the sun set or "died" each evening.

The birth of a child is enabled through the womb of the physical mother while birth into the heavenly realms is effected through the womb (or duat) of the cosmic mother. Out of these birth canals, the

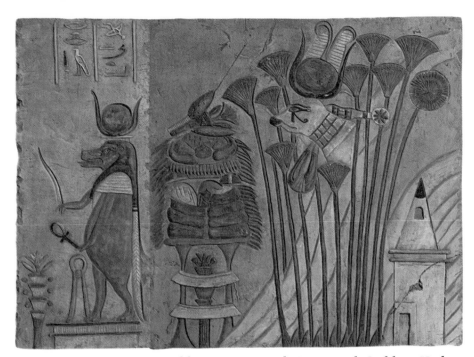

Fig. 42, Hippopotamus Goddess Taueret and Cow-Faced Goddess Hathor Herald New Birth

Placing "Hippopotamus Goddess Taueret and Cow-Faced Goddess Hathor Herald New Birth" in your home or office encourages birth, new beginnings, celebration, growth, fulfillment, spiritual insight, clear vision, motherly instinct, truth, protection, compassion and balance of opposing elements.

newly born emerges into the Light and thus "comes forth by day." **Fig. 42** shows the netert of birth, **Taueret,** with the pregnant body and face of a hippopotamus, the legs of a lion and the tail of a crocodile. She holds the ankh, symbol of life, in her left hand and the eternal flame (**py-ra-mid**) in her right hand. At her feet is the **sa,** symbol of protection. She wears the horned sun disk of Hathor, associating her

once again with birth. An offering table is heaped lavishly with foods and decorated with garland and lotus flowers, symbolizing the celebratory nature of the new birth. Hathor, the netert of love and

Fig. 43, Ani Reborn as a Lotus and Greeted by the Bennu Bird

Placing "Ani Reborn as a Lotus and Greeted by the Bennu Bird" in your home or office evokes transformation, renewal, regeneration, higher consciousness, purity, vitality and good health, beauty, self-mastery, fulfillment, and heavenly bliss.

birth, emerges in the form of the celestial cow from the Western Mountain where royal and private tombs were typically situated. Ani's

own pyramidal-topped tomb is in the forefront. The mountain simultaneously symbolizes the west bank or geographical location of the dead as well as the primordial mound associated with creation and new life. This is further emphasized by the marsh of living papyrus flowers that have sprung to life beside the tomb at the base of the mound. Hathor's eye is in the form of the **udjat,** offering protection and clear vision, and she wears the horned solar disk adorned with two feathers of truth and a **menit** necklace.

The "newly born" Ani is shown in **Fig. 43** emerging anew from a **lotus** flower. This scene is associated with Spell 81A of the *Book of Coming Forth by Day,* "Chapter for Being Transformed into a Lotus." Like the lotus that closes at night and blooms with the light of day, Ani's consciousness has transformed from death to life. He emerges into the "day," his soul pure and unblemished like the sacred white lotus flower whose roots are firmly embedded in the earth, its body floating within a watery womb, its flowery petals opened to receive the heavenly breath of life. As previously mentioned, the chakras contained within the physical human body are referred to as lotuses whose petals unfold with the proper practice to receive the heavenly **manna** or "food of the gods."

It was believed by the ancient Egyptians that upon entering the heavenly realms the deceased would be greeted by the **bennu** bird, a large blue heron or phoenix symbolizing birth (similar to our own myth of a stork bringing new babies into the world). The bennu bird is also associated with the **ben ben,** an obelisk or conical-shaped object that represented the primordial first ray of light as it touched the earth,

dispelling the dark and chaotic cosmic soup of **Nun**. A ben ben was enshrined in the cult city of Heliopolis, and it's speculated that the unusual relic may have been a meteorite. As the meteorite fell to earth in flames, it probably looked like a bird with flaming wings. Perhaps upon investigating the unusual event, a large bird coincidentally appeared near the rock, provoking the myth of the phoenix rising amidst flames and ashes. In any event, the blue heron and phoenix became mythically associated with renewal of the deceased. **Fig. 43** depicts the bennu bird wearing the **atef** crown associated with Osiris, the neter of resurrection.

A spell for being transformed into a phoenix from the *Book of Coming Forth by Day* reads as follows,

> *I have flown up like the primeval ones, I have become Khepri, I have grown as a plant, I have clad myself as a tortoise, I am the essence of every god, I am the seventh of those seven uraei who came into being in the West, Horus who makes brightness with his person, that god who was against Seth, Thoth who was among you in that judgment of Him who presides over Letopolis together with the Souls of Heliopolis, the flood which was between them. I have come on the day when I appear in glory with the strides of the gods, for I am Khons who subdued the lords.*
>
> *As for him who knows this pure spell, it means going out into the day after death and being transformed at will, being in the suite of Wennefer, being content with the food of Osiris, having invocation-offerings, seeing the sun; it means being hale on earth with Ra and being vindicated with Osiris, and nothing evil shall have power over him. A matter a million times true.*[6]

[6] *The Ancient Egyptian Book of the Dead,* 80–81.

7

WEIGHING OF THE HEART

The culminating point in the Egyptian initiatic or death experience is the **Weighing of the Heart,** a formal ritual and judgment of the deceased or **initiate** by the most highly revered **neteroo**. This theme prolifically appeared in tombs, on **papyri,** coffins and linen wrappings and, even today, more reproductions of this scene are sold by papyri vendors than any other.

Fig. 44 shows a typical rendition of the scene with the jackal-headed **Anubis** escorting the deceased Hunefer into the second phase of the **Double Hall of Truth.** As a loyal and protective guide, Anubis gently holds the left hand of Hunefer while carrying the **ankh** of life in his other hand. The scales of truth stand before the couple,

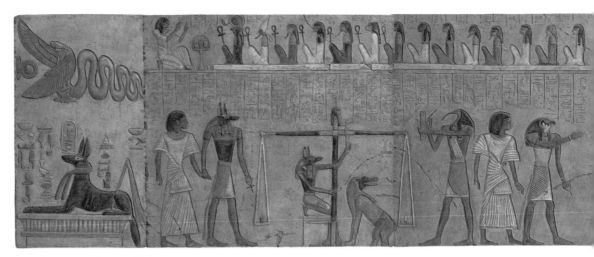

Fig. 44, Weighing of the Heart

Placing "Weighing of the Heart" in your home or office cultivates a pure and happy heart, the ability to listen and respond to one's own "inner knowing," development of wisdom in order to overcome negative karma, and realization of ultimate Truth.

topped with the white feather of **Ma'at.** The kneeling Anubis checks the balance on behalf of Hunefer while the monstrous creature **Ammit** hungrily hopes to devour any remains of impurity. Hunefer's heart is balanced on the left side of the scale against the feather of truth on the right. If the scale remains balanced, Hunefer is decreed "justified"; however, if the scale weighs heavy, the impurities of the heart must be eliminated so that Hunefer's soul is not "damned." Thus, the creature Ammit (the curse word [d]ammit may have originated from this mythical beast) devours the impurities so that the soul may remain pure and free of karma. The ibis-headed **neter** of wisdom **Thoth** diligently records the results for inclusion in the Book of Life. The successful and smiling initiate is escorted by the hawk-headed **Horus** to meet the

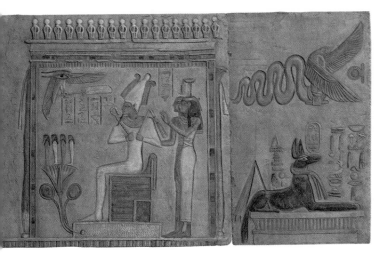

presiding judge **Osiris.** Osiris is seated in his royal throne upon the Lake of Natron, denoted by the wavy lines in the bier beneath his feet. He appears in **mummiform** wearing the double-plumed white **atef** crown and holds the **crook and flail.** A lotus flower blooms from the waters upon which stand the **Four Sons of Horus** in order to protect the internal organs of the initiate. **Nephthys** and **Isis** stand behind the judge with hands raised in the mudra (hand posture) of fearlessness to reassure and formally greet Hunefer. Hunefer pays respect to the Heliopolitan Ennead (minus **Set**) as well as Utterance, Perception and the Cosmic Directions (or "ways") in the register above. The reclining figure of the jackal Anubis and the cobra **Wadjet** appear at entry and exit of the Great Hall as protective talismans.

8

RA RISING

The **heb-sed** or jubilee festival was conducted as a rite of renewal to celebrate the pharaoh's successful rulership and unification of the two lands, Lower and Upper Egypt. The **pharaoh** performed a ritual run and other tests of endurance to prove he was physically fit despite age or length of rule. The heb-sed was thought to be an alternative to the predynastic practice of regicide, the slaying of an aged king.[1] The highlight of the celebration was the enthronement of the pharaoh in two special pavilions, one in which he was crowned wearing the flat red crown of Lower Egypt,

[1] Wilkinson, *Reading Egyptian Art: A Hieroglyphic Guide to Ancient Egyptian Painting and Sculpture*, 145.

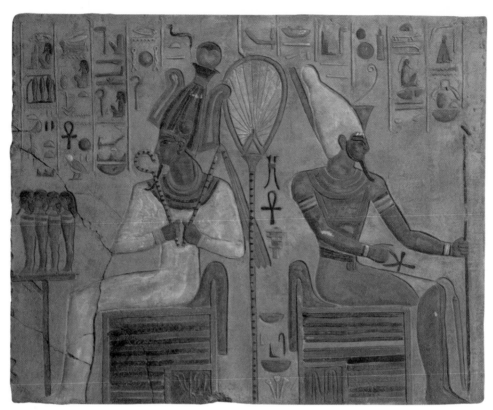

Fig. 45, Jubilee Uniting the Two Lands

Placing "Jubilee Uniting the Two Lands" in your home or office promotes victorious celebration, power, recognition, renewal, longevity, endurance, unification of yin and yang (opposing elements), as well as self-mastery.

and the second in which he was crowned wearing the domed white crown of Upper Egypt. Typical artistic renditions of the festival portray the pharaoh during the crowning ceremony seated in mirror image back-to-back with himself, symbolizing the unification of the two lands.

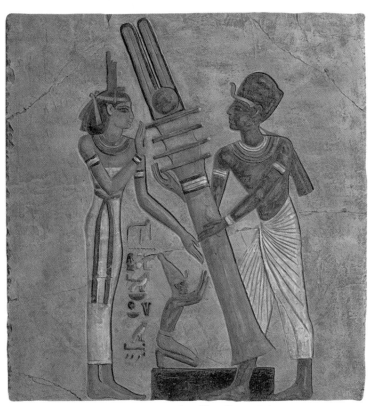

Fig. 46, Seti I Accepting Djed Pillar from Isis

Placing "Seti I Accepting Djed Pillar from Isis" in your home or office promotes stability, duration, longevity, virility, power, recognition, victory over adversity, successful achievement, and jubilant celebration of life.

Fig. 45 similarly represents a jubilee of renewal; however, rather than a pharaonic celebration, two **neteroo** are seated back-to-back: **Osiris,** the **neter** of death, and **Atum,** the neter of creation. The deeper symbolism of this scene is the resolution and unification of

duality by the deceased or **initiate** and admittance into the company of neteroo. In other words, the successful initiate resolves conflict between duality: lower instinct versus higher inspiration; evil versus good; death versus life; "form" versus "formlessness"; all symbolized by the **Double Hall of Truth**. The point of balance is the heart, the middle path, which results in unification—Oneness. Once this resolution is achieved, the "king" is "crowned." Simply put, the initiate has successfully mastered "self" (i.e., "rulership"), resulting in coronation or the "crown" (the halo of light associated with the "crown" chakra of enlightenment or ultimate Truth, **ma'at**).

Another ritual enacted during the heb-sed jubilee was the erection of the **djed** pillar. A similar ceremony was also performed at the death of the pharaoh. A detailed description of the djed and its symbolism is presented in the Hall of Truth chapter. To reiterate, the djed symbolizes stability and resurrection and is associated with the myth of Osiris. After the brutal murder of Osiris by his evil brother **Set,** Osiris's dead body floated in the Nile and became embedded in the trunk of a Tamarisk tree. The tree was cut down and used as a pillar in the palace of the king and queen of Byblos. Osiris's wife **Isis** retrieved the tree and, with the assistance of the magical knowledge of **Thoth,** performed a ritual that restored life to Osiris. Thus the djed became the symbol of resurrection to the ancient Egyptians much in the manner that the cross became the symbol of resurrection to Christians of later times. The ancient Egyptians of the New Kingdom routinely painted a djed on the bottom of a coffin aligned with the spine of the deceased, thereby providing the deceased with a tool of resurrection. The deeper esoteric implication of

the djed relates to the intentional raising of **qi** via the breath along the spinal column to evoke enlightenment. In **Fig. 46**, Pharaoh **Seti I** accepts a djed pillar from Isis, ensuring the stability of his royal reign and ultimate union with the Divine.

Theoretically, death has the potential to be as awesome and beautiful as birth itself because the two states are not dissimilar. Unfortunately, death is often anticipated with trepidation and fear, and many rites of initiation are commonly viewed as ineffective unless experienced as arduous trials of psychic and physical endurance. Although prolonged states of suffering may ultimately result in transcendence and empowerment, such as the incredible Sun Dance of Native Americans in which the chest is pierced and tethered as the initiate dances for four consecutive days without food or water, it is also true that transcendence may occur in playful, joyous states of awareness without the need to suffer. As an example, it is not at all uncommon in Buddhist monasteries for the high lamas to choose their time of death, to sit in formal meditation in the presence of other monks, to collapse their physical form in a burst of rainbow light and dematerialize into the Buddhic realms. Called the "Rainbow Death," this practice is so common that according to a very prominent author of Tibetan Buddhist practice, every fourth or fifth monk has witnessed the phenomena and considers it "no big deal." To we Westerners, an act such as this seems not only miraculous but practically unbelievable! It is further recognized that not only can the meditation master collapse his or her physical form and move into the heavenly realms, but he or she also has the ability to manifest a physical form body and reappear on

Earth in order to motivate others to enlightenment. This ability to move freely from one realm to another is frequently referred to in ancient Egyptian texts. Spell 68 of the *Book of Coming Forth by Day* specifically states:

> *As for whoever knows this book (Spell 68), he shall go out into the day, he shall walk on earth among the living and he shall never suffer destruction. A matter a million times true.*[2]

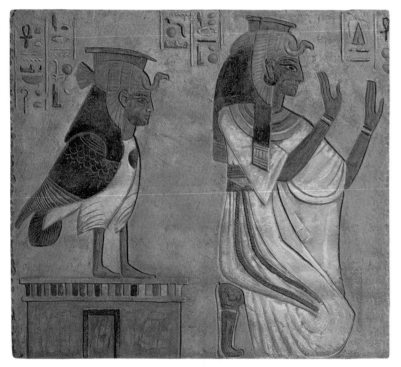

Fig. 47, Queen Nefertari Kneeling in Front of Her Ba (Soul)

Placing "Queen Nefertari Kneeling in Front of Her Ba (Soul)" in your home or office creates wholeness, completeness, a bridge between yesterday and tomorrow/heaven and earth, meditative awareness, the ability to transcend the mundane and move freely without impediment.

[2] *The Ancient Egyptian Book of the Dead,* 70.

The Egyptians present an alternative to facing death with fear; rather, they view death as an extension of life, full of wonder, joy and play. Queen **Nefertari,** wife of the great Pharaoh **Ramses II,** is shown enjoying a board game of **senet** in the afterlife on the walls of her tomb (see Fig. 16). In the scene that follows the game of senet in her tomb, Nefertari is shown kneeling in front of her **ba,** a bird with the queen's head representing her soul (see **Fig. 47**) with her hands raised in honor of two lions with the sun disc between them (not shown). The two lions symbolize "yesterday and tomorrow," the "past and the future."

If the deceased were incapable of maintaining some type of physicality following death, it would seem logical that only the ba would be portrayed. That both the soul and the physical form of the deceased are simultaneously represented suggests the Egyptians' philosophy to be similar to that of the Tibetans: that moving freely between "form" and "formlessness" is perfectly possible and natural.

What kind of magic permits an individual to have the ability to master the atom, to move between the worlds, to utilize the properties of quantum mechanics, to manifest wine and bread out of thin air for the benefit of others, to walk on fire or water, to part the seas? Certainly it is more than the recitation of simple spells and texts, and yet perhaps these ancient writings hold the fundamental clues to access deeper wisdom *within* that can transform the "ordinary" into "extraordinary." This process is known as **alchemy.** Many "myths" abound of the magical prowess of the Egyptian alchemists, their ability to defy laws of gravity by levitating large blocks of stone weighing tons, the ability to transform base metal into gold, to perform

extraordinary feats of healing that would be considered miraculous by today's standards.

Is there any basis of truth to these stories or are they, in fact, mere myths? If true, what tools provoke this alchemical process?

Fig. 48 offers a response to this intriguing question. Isis and **Nephthys,** representing two polarized aspects of the **yin** body, kneel on **nebu,** the Egyptian **hieroglyph** for gold. The nebu is actually a pictograph of a gold collar or necklace. The Egyptians considered gold a precious material because it is imperishable and the color of the sun. It was also equated with alchemy—the transformation of base metal into gold—representing the initiate who has transformed from being "ordinary" into "extraordinary" or the deceased who transcends from a state of mortality to immortality. In fact, a sacred dance was performed during funerary rites in which two dancers' bodies imitated the position of the sign for gold. Called the **tcheref,** this rite enabled the deceased to remain imperishable and radiate Divine Eternal Light.[3]

The two neteroo, Isis and Nephthys, are positioned on either side of the djed pillar symbolizing the Ida, Shushuma and Pingala, respectively (see text accompanying Fig. 37 for more detail). Above the djed pillar, associated with the spinal column on a physical level and the Shushuma on an etheric level, is the **ankh** of eternal life, with two upraised human arms and hands embracing the sun. Seven dog-faced baboons give praise to the sun above the two neteroo. The baboons represent the evolution of consciousness that is expressed through the seven **chakras**. The dog-faced baboon is a pun for the dog-star Sirius and the union between evolutionary humanity and

[3] Wilkinson, *Reading Egyptian Art: A Hieroglyphic Guide to Ancient Egyptian Painting and Sculpture,* 171.

solar-consciousness. The ancient Egyptians believed that upon achieving a state of alchemical transformation, every being achieved the radiance and illumination of a living star such as Sirius, Pleiades and Orion, in particular. Above the sun is an arched symbol called the

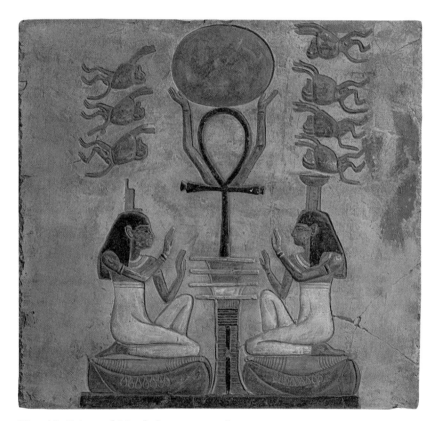

Fig. 48, Isis and Nephthys Praise the Rising Sun

Placing "Isis and Nephthys Praise the Rising Sun" in your home or office promotes balance between yin and yang; unification of body, mind and spirit; knowledge of alchemy and the mystical arts; higher wisdom; prosperity, good fortune and well-being; longevity and radiance.

pet representing the sky. (Some of these symbols have been truncated due to space considerations.)

The djed, ankh and sun represent various aspects of the human constitution. The djed is associated with the lower trunk and legs of the human body, the ankh the upper trunk or chest, arms and head, and the sun signifies the illumined crown. In turn, these aspects also signify body, heart and spirit unified as One.

The significance of the above must not be understated; however, it should *not* be misinterpreted to suggest that alchemical transformation or enlightenment may only occur with knowledge of yogic breath. In fact, at a fundamental level, this scene suggests that higher consciousness may be achieved by unifying duality (inner conflict) and elevating awareness to the Light of Divine Heart-Mind.

Sometimes we're so focused on the conflicts of the "outer" world that we ignore conflicts "within." How many of our thoughts are negatively oriented? How much time is spent obsessing about what is wrong with our lives, our bodies, our job, our finances, acquaintances and loved ones, rather than appreciating the gift of every moment, seeing the beauty of the mundane, the "gold" inherent in each and every "ordinary" thing? Mother Teresa often spoke of seeing the body of Christ in the diseased and filthy people she lovingly ministered to on the streets of India. She saw beyond the maya (illusion) of the individual and his/her circumstances and into soul—the radiant imperishable star, the gold, the jewel, the Divine Heart-Mind—and could therefore lovingly appreciate the individual by recognizing self and other as One. This is the true meaning of yoga: Union!

Fig. 48 symbolizes the union of lower and higher consciousness that results in resurrection and immortality.

9
OPENING OF THE MOUTH

One of the most mysterious of all Egyptian rituals is the **Opening of the Mouth**
ceremony. This rite was initially performed on statuary of **neteroo** and **pharaohs**
for oracular purposes. By the Middle Kingdom, the practice expanded to include
mummies and sarcophagi. In addition, the priesthood employed the practice as an ini-
tiatic rite on the pharaoh who acted as an intermediary between the neteroo and the
public to communicate Divine law. The ritual itself consisted of purification, censing
and lightly touching or striking the mouth of the statue, pharaoh, mummy or **initiate**
with an **ankh** or iron adze in order to provoke Divine Utterance. The ancient Egyptians
regarded iron as the "metal of heaven" because of its meteoritic origin. They associated

it with the seed of Ra-Atum that spilled from the heavens and believed it had a generative quality. It was therefore used in special amulets and tools to ensure the continuity of life.

Fig. 49 shows the **neter** of wisdom, the ibis-headed **Thoth**, performing the sacred Opening of the Mouth ceremony on Pharaoh **Seti I.** The deceased pharaoh is dressed in **mummiform** and holds the traditional emblems of royalty, the **crook and flail.** He wears the double-plumed **atef** crown with ram's horns, double uraei and three solar disks. The ram's horns signify virility and regeneration, the double plumes **ma'at** (or truth) as well as unification between the two lands (Upper and Lower Egypt; higher and lower self). The raised uraei symbolize mastery of the two forces of **kundalini** and **qi** within the body and the three solar disks represent the Trinity. In between Seti and Thoth is a stand with two vessels, probably containing water for purposes of purification, and a planter with **lotus** flowers symbolizing rebirth. Thoth is portrayed with a white sash across his chest indicating his role as a lector priest as he holds two staves with entwined cobras wearing the white and red crowns of Upper and Lower Egypt. The staves represent the **caduceus,** an emblem associated with medical knowledge said to derive from Thoth himself. Once again, the two staves and raised cobras represent the "ascended" kundalini and qi as well as unification of the two lands. Thoth touches the lips of the pharaoh with the ankh of life thus invoking the opening of the pharaoh's mouth.

This procedure generates cosmic breath—the breath of the Divine— to flow through the initiate. When the Divine exhales, the initiate inhales and when the initiate exhales, the Divine inhales. The sacred

breath or "wind" produces spontaneous sound—Divine Utterance or the Word—which in turn manifests matter or form. Thus, initiation is complete, the mouth is open, and the successful candidate joins the company of neteroo as co-creator with the Divine. **Ra** has risen!

Spell 23 for Opening the Mouth in the **Book of Coming Forth by Day** reads as follows:

> My mouth is opened by Ptah and what was on my mouth has been loosened by my local god. Thoth comes indeed, filled and equipped with magic, and the bonds of Set which restricted my mouth have been loosened. Atum has warded them off and has cast away the restrictions of Set.
>
> My mouth is opened, my mouth is split open by Shu with that iron harpoon of his with which he split open the mouths of the gods. I am Sekhmet, and I sit beside Her who is in the great wind of the sky; I am Orion the Great who dwells with the Souls of Heliopolis.
>
> As for any magic spell or any words which may be uttered against me, the gods will rise up against it, even the entire Ennead.[1]

The above passage suggests tantalizing stellar implications. Indeed, in recent years, some interesting theories have come forth concerning the full implication of this rite. Alternately used with the ankh in Opening of the Mouth, the iron adze is referred to as the "Adze of Upuaut" in the Pyramid Texts. **Upuaut** is the jackal-headed neter known as the "Opener of Ways." Sometimes this role is assumed by the jackal-headed neter **Anubis,** the illegitimate son of **Osiris** and **Nephthys.** In addition, Upuaut is also the name of the small robot that

[1] *The Ancient Egyptian Book of the Dead,* 51–52.

was utilized by Rudolph Gantenbrink in the exploration of the air-shafts in the Great Pyramid in 1992 to 1993.

According to authors Robert Bauval and Adrian Gilbert in *The Orion Mystery,* the Canadian Egyptologist Mercer, who translated the Pyramid Texts in 1952, noticed that the Egyptian adze was shaped like the constellation Ursa Major and was called *meshtw* (the "thigh") by the Egyptians. Bochardt, a German Egyptologist, suggested the adze more clearly favored the Little Dipper, Ursa Minor, in the shape of a foreleg of an ox that bends forward.[2] Gantenbrink's robot discovered the air-shafts of the Queen's chamber in the Great Pyramid assume a shape identical to the adze and that the northern shaft is, in fact, aligned with Ursa Minor while the southern shaft is aligned with Sirius. The theory is further fueled by a myth related to **Horus,** the son of **Isis** and Osiris, in which Horus opens the mouth of his father with an iron adze after Osiris's brutal murder by the evil **Set,** setting into motion the starry essence that is the dust or seed of all form. (Remember the passage in *The Little Prince* in which the little prince exclaims, "Oh my gosh, I'm full of stars!")

The pyramid texts reveal that the Opening of the Mouth ceremony was often performed on the deceased pharaoh by his son, symbolizing Osiris and Horus, respectively. The pharaoh's son ritually wore a Horus mask and was accompanied by four individuals representing the **Four Sons of Horus.** Ursa Minor is comprised of, you guessed it, four stars!

It is Bauval and Gilbert's contention that the Great Pyramid was used as a special ceremonial sanctuary where the initiate or mummy was transported, followed by the Opening of the Mouth ceremony in the

[2] Robert Bauval and Adrian Gilbert, *The Orion Mystery: Unlocking the Secrets of the Pyramids* (New York: Crown Publishers, Inc.), 206.

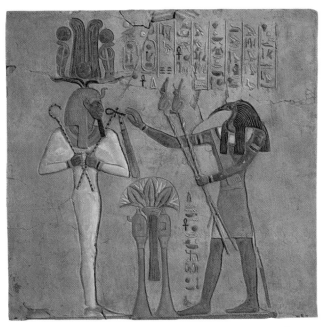

Queen's chamber, and the temporary placement of the initiate or deceased in the stone **sarcophagus** in the King's Chamber until he/she transformed into an imperishable star via the "roads of Osiris in the sky," which are directionally indicated by the air shafts in the King's chamber. The ancient Egyptian *Book of Two Ways* from the Middle Kingdom lends support to this theory by stating:

> *I have traveled by the roads of Rostau[3] on water and on land . . . these are the roads of Osiris; they are in the sky.[4]*

Fig. 49, Thoth, the God of Wisdom, Opening the Mouth of Pharaoh Seti I

Placing "Thoth, the God of Wisdom, Opening the Mouth of Pharaoh Seti I" in your home or office enhances communication, the ability to effectively interpret spatial concepts, manifest ideas into reality, integrate macrocosmic and microcosmic elements, circulate breath for enhanced health and vitality, channel Divine wisdom, and achieve self-realization.

[3] *Necropolis associated with the Giza plateau.*
[4] Bauval and Gilbert, *The Orion Mystery: Unlocking the Secrets of the Pyramids,* 212.

10

THE FLOWER OF LIFE

Temples, pyramids and sacred sites around the world often contain similar symbols, artifacts and mystical references despite vast geographical distance and differing time frames. One such symbol is the **Flower of Life** represented in **Fig. 50.** Its origin is unknown but the symbol dates back to ancient times and has been found in temples in Japan, China, Israel, India and Egypt.

What is the significance of this symbol and how does it commonly relate to such diverse worldwide cultures and religions? Simply put, it's a geometric map that reflects the codes of creation. As you probably know, scientists recently decoded the sequence of human DNA, the genetic mechanism by which human life begins and is passed on

133

from generation to generation. Similarly, the Flower of Life contains the codes to the *cosmos* as a whole, including humans and all third-dimensional life forms. These codes are called Platonic Solids. They're named after the great philosopher Plato due to his theory that the universe is the result of an assemblage of interlocking geometric patterns. In fact, all matter results from one, or a combination of one or more, of five Platonic Solids. In sacred geometry, these five forms are known as the tetrahedron, hexahedron, octahedron, dodecahedron and icosahedron and are contained within the Flower of Life.[1]

The Flower of Life is the source of varying philosophies, teachings, sciences, arts and religions. In Eastern traditions, such as Buddhism and Taoism, it is known as the Golden Flower. Richard Wilhelm was the first to introduce the Golden Flower teachings to the West in 1929 with a translation in German of an ancient Chinese manuscript. His book was called *The Secret of the Golden Flower: A Chinese Book of Life.* It was translated into English shortly thereafter with commentaries in both German and English by the renowned psychologist C. G. Jung. In 1991 Thomas Cleary offered a revised translation due to his dissatisfaction with the Wilhelm version called *The Secret of the Golden Flower: The Classic Chinese Book of Life.* Authors/lecturers Drunvalo Melchizedek and Gregg Braden have also contributed to unlocking the mysteries of this ancient symbol in contemporary books on the subject (see footnote).[2] Each interpretation offers a unique potential like the combination of the Platonic Solids themselves, which may be

[1] Gregg Braden, *Awakening to Zero Point: The Collective Initiation,* Sacred Spaces/Ancient Wisdom, 1994, pgs. 126–128.

[2] Drunvalo Melchizedek, *The Ancient Secret of the Flower of Life, Volumes 1 and 2,* (Flagstaff, Ariz.: Light Technology Publishing, 1998 and 2000); and Gregg Braden, *Awakening to Zero Point: The Collective Initiation,* Sacred Spaces/Ancient Wisdom, 1994.

assembled in infinite interacting templates to express the whole.

In Egypt, the Flower of Life symbol was discovered in the most holy of sites, **Abydos,** the place where every ancient Egyptian strived to make a sacred pilgrimage at least once in his/her lifetime. Specifically, it was discovered in the Osirian, the *middle* temple associated with the resurrection of **Osiris.** The Osirian predates the other structures at Abydos and was buried in the sand when the **Seti I** complexes were built. Its architectural design is dissimilar to the other temples and its true age, like the Great Sphinx, is a source of great controversy. Curiously, the Flower of Life symbols do not appear to be carved or painted on the temple walls but flashed-burned.[3]

In the Egyptian and Taoist Flower of Life traditions, an emphasis is placed on circulating the breath in specific geometric patterns throughout the body as reflected in the templates of the symbol itself in order to accelerate the **chakras**; however, in the Zen Buddhist tradition, specific technique is not required as unfoldment is considered spontaneous. Subsequently, the Flower of Life offers an "awakening," a "coming forth by day" for seekers and non-seekers alike, Buddhists, Taoists, Christians, Jews, Hindus, men and

Fig. 50, Flower of Life

Placing "Flower of Life" in your home or office evokes infinite potential, transformation, mastery of breath, geometry and physics; the ability to decode the mysteries of life and death, and experience ultimate realization and universal Oneness.

[3] Braden, *Awakening to Zero Point: The Collective Initiation,* 135.

women of all religions, races, lands and creeds—sans dogma or bias. The Flower of Life templates resonate with the observer and unlock universal codes within, opening the "heavenly gates," alchemically transforming the **initiate** into a golden **lotus,** a radiant imperishable star!

Essential to this process is "turning the light around." This means experiencing the "inner" and "outer" light as nondifferentiated. In *The Secret of the Golden Flower* it is said, "Where did the term *turning the light around* begin? It began with the adept Wenshi. When the light is turned around, the energies of heaven and earth, yin and yang, all congeal. This is what is called 'refined thought,' 'pure energy,' or 'pure thought.'"[4] In other words, when the light is turned around, the petals of the heart chakra open to reveal the "fire-in-middle," the imperishable **py-Ra-mid,** the Jewel within the center of the Lotus, the gold, the "imperishable radiant star" that is One.

[4] *The Secret of the Golden Flower, The Classic Chinese Book of Life,* trans. and commentary by Thomas Cleary (New York: HarperCollins Publishers 1991), 17.

The Imperishable Radiant Star

Desireth thou to know the deep, hidden secret?
Look in thy heart where the knowledge is bound.
Know that in thee the secret is hidden,
the source of all life and the source of all death.

List ye, O man, while I tell the secret,
reveal unto thee the secret of old.

Deep in Earth's heart lies the flower,
the source of the Spirit that binds all in its form.
For know ye that the Earth is living in body
as thou art alive in thine own formed form.
The Flower of Life
is as thine own place of Spirit
and streams through the Earth
as thine flows through thy form;
giving of life to the Earth and its children,
renewing the Spirit from form unto form.[5]

—Excerpted from *Emerald Tablet XII:*
The Keys of Life and Death

[5] Doreal, *The Emerald Tablets of Thoth the Atlantean,* Alexandrian Library Press, Second Printing.

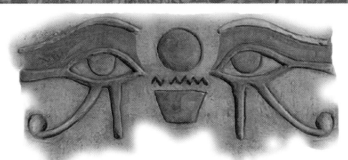

THE EGYPTIAN ORIGINS OF READING ETC.

Ancient Egyptian architectural structures consisted of common design elements including facades, pillars, statuary, friezes, wall paintings and gardens to create institutions of duration, precision, beauty and harmony. The Egyptian-themed showroom of **Reading Etc.** is complete with characteristics typical of ancient Egyptian architectural design, motivated by a visit to Harrods in London by Peter Vegso, president of Health Communications, Inc. and proprietor of Reading Etc. A series of classic Egyptian friezes on the walls of the famous store evoked in Peter a sense of appreciation, awe and curiosity about the ancient culture—and the rest is history. The premier showroom of Reading Etc. located in Deerfield Beach, Florida, opened its doors to the public in September 2000 with plans for forthcoming locations nationwide. Reproductions of original Egyptian statuary, temple and tomb art (described in detail in this book) may be viewed as you stroll through the Flagship Showroom in addition to live **papyrus**, the plant made into paper by the ancient Egyptians, and other exotic plants in the lovely outdoor garden.

Information regarding the talented team of artisans involved in the Reading Etc. project may be found in the Addendum to this book.

A brief description of actual statuary and other design elements follows:

SAMI THE SCRIBE

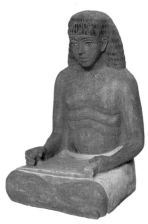

Scribes were accorded an elite position of prestige, privilege and honor in ancient Egypt. According to the ancient Egyptian text *The Instruction of Khety*, "The **netert** (goddess) of abundance was carved on the scribe's shoulder from the day he was born." Since less than 1 percent of the population was literate, a skilled and trustworthy scribe was considered invaluable. They alone were privy to official proclamations, diplomatic correspondence, legal documents, administrative, economic and spiritual documents, tax records, wills and personal correspondence.

Formal texts were written in a series of comprehensive pictographs called hieroglyphics. The word **hieroglyph** is Greek in origin and means "holy writings." More than 750 hieroglyphs are known in the ancient Egyptian language. Egyptian hieroglyphs are divided into three main classes consisting of ideograms, phonograms and determinatives. Ideograms

are pictures that graphically represent an object, whereas phonograms express the phonetic sound of the name of the object, generally consisting of two or more consonants. Since hieroglyphics are written right-to-left and left-to-right and sometimes vertically from top-to-bottom with no vowels or spaces in between, determinatives are used to designate sentence endings and the direction of the text. Generally, determinatives are pictures of animals or figurines that indicate the proper direction of the text by the position they face.

Everyday correspondence of a less formal nature was written in a cursive style called *hieratic*. A shortened version of this style of writing was adopted in late dynastic Egypt called *demotic*, meaning "the people's language" and from this the *Coptic* style associated with the Ptolemaic period derived (which follows basic Egyptian structure but includes Greek letters). Egyptian texts were largely undecipherable until 1799 A.D. with the discovery of the **Rosetta Stone** by French troops near the town of Rosetta in Lower Egypt. The stone is a slab of black basalt inscribed in three scripts (hieroglyphic, demotic and Greek) in praise of the Egyptian **Pharaoh** Ptolemy V.[1] The stone proved to be the key for decoding the obscure Egyptian language after twenty years of study by the French Egyptologist Champollion. The original is presently displayed in the British Museum, London.

From an early age, scribes studied and trained in schools called *per-ankh*, meaning "House of Life" or "House of Eternity,"

[1] *Microsoft Encarta Enclyclopedia*, 1999.

probably so-named because knowledge and the written word frequently outlived its source as it was passed from generation to generation.

Young scribes practiced writing with reed pens on pottery shards, pieces of limestone and paper made from papyrus plants that grew along the banks of the Nile. The art of making paper from papyrus continues in Egypt even today. The inner pith of the papyrus stem is sliced in strips and laid side-by-side slightly over-lapping each other on top of a piece of cloth placed on a hard, flat surface. Additional strips are placed on top of and at right angles to the first layer and covered with a second piece of cloth. The pith is then beaten with a mallet or flat rock that causes a starchy glue to exude and bind the flattened plant fibers together. The cloth is then removed and the paper placed in the sun to dry. The paper is polished by rubbing it with a smooth stone.

Life-sized sculptures of an unknown scribe seated with writer's pallet in lap and a papyrus scroll in hand are strategi-cally placed throughout Reading Etc. setting a tone of reading, writing, wisdom and enlightenment. One day, Peter Vegso, the proprietor of Reading Etc. referred to the scribe as Sami. The name stuck and the formerly nameless scribe continued to be addressed as Sami throughout the many months of planning and building the store. Even today, he continues to be referred to as Sami the Scribe. This seems especially appropriate since learning is best effected in an atmosphere of creativity, fun, and personal interaction!

TILED MOSAIC

One of the oldest stone complexes in the world is Saqqara built in the third dynasty for the Pharaoh Djoser by his chief architect Imhotep. The *Turin Papyrus*, a document attributed to the Nineteenth Dynasty listing the historical names and dates of Egyptian Pharaohs, gives particular recognition to Djoser by the addition of a special summary.[2] Imhotep's fame may have exceeded that of the pharaoh in that he was deified as a **neter** some 2,000 years after Djoser's rule, in addition to his official titles as sage, architect, high priest, astronomer and doctor.[3]

Prior to the Third dynasty, royal tombs called mastabas were composed of mud bricks in a rectangular shape with sloping sides and a subterranean chamber. Imhotep was the first known architect to build the mortuary structure out of stone rather than mud. The royal tomb at Saqqara was originally designed as a three-tiered step **mastaba** that was converted into a six-tiered stepped **pyramid** in subsequent phases. It is historically recognized as the oldest of the Egyptian pyramids

[2] *Egypt: The World of the Pharaohs* (Germany: Konemann Verlagsgesellschaft/GmbH, 1998), 47.
[3] John Anthony West, *The Traveler's Key to Ancient Egypt* (New York: Alfred A. Knopf, 1989), pg. 158.

outdating the Great Pyramid itself. The Djoser complex consists of the six-tiered stepped pyramid with the subterranean royal tomb to the north, a smaller mastaba to the south (both with similar underground structures), a mortuary temple, ceremonial courts, chapels and stone enclosure. Chambers and passageways beneath the pyramid represent the celestial palace of the pharaoh for his use in the afterlife. Large sections of the underground chamber walls are covered in exquisite turquoise porcelain tiles referred to as the "Blue Chambers."

A stunning reproduction of a main panel from an underground chamber in the northern pyramid topped with an archway of **djed** pillars (associated with the neter **Osiris** and symbolizing resurrection) is beautifully displayed behind the coffee bar in Reading Etc. It was painstakingly handcrafted piece by piece by artisans, just like the original.

FLOCK OF BIRDS CEILING ART

Look up at the ceiling in any ancient Egyptian temple and you may be surprised to find some of the most beautiful art of the whole temple. Adorning the ceiling above the coffee bar at

Reading Etc. is a lovely mural of a flock of birds, a popular decorative element in ancient Egyptian art appearing on furniture, pottery, ivory combs, temple and tomb walls. The mural was inspired by a similar design on a silk scarf given to Peter Vegso's wife, Anne, by Harrods' chairman Mohamed Al Fayed while visiting the famous store. Many birds held mystical significance to the ancient Egyptians. The goddesses **Isis** and **Nephthys** changed into kites or swallows when performing magical rituals, for instance, and the sun god **Ra**, as well as **Horus**, the protectorate of the pharaoh, were commonly depicted as falcon-headed. In addition, the soul of the deceased, known as the **ba**, was artistically represented as a human-headed bird.

STATUES OF PTAH AND AMON

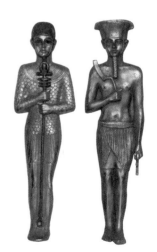

Amongst the friezes that grace the interior perimeter of Reading Etc. are two golden-colored statues that refer to Egyptian creation myths. One of the statues is a likeness of **Ptah**, known as the Divine architect of the Universe, whose tongue uttered the name of everything and caused it to come into existence. Ptah was especially revered in Memphis, the oldest city of dynastic Egypt, and was referred to as the "Greatest of Craftsmen." Architects, engineers, stonemasons, metalworkers, shipbuilders and

artists showed particular favor for this neter into the late dynasties. Ptah was frequently associated with the **Apis** bull, a cult symbol of Memphis, denoting virility, stamina and fertility. Paradoxically, he was also depicted in **mummiform** wearing a skullcap, as in this particular statue. He holds a scepter with both hands incorporating elements of the **ankh, uas** and djed, the tip of which touches his false beard.

The other statue is of **Amon,** whose name means "Hidden One" and who gained great prominence in the Middle Kingdom and was primarily associated with the city of Thebes. He was referred to as the face of Ra and the body of Ptah and was believed capable of assuming any form he wished. Worship of this neter remained steady until interrupted by the brief reign of the pharaoh **Akhenaton,** who banned the existing pantheon in favor of one deity, **Aton**. Amon worship was restored upon Akhenaton's death by the successor to the throne, the young boy-king **Tutankhamon**. It was said the soul or essence of Amon is enshrined in ram-headed sphinxes, the ram being a symbol of fertility and protection. Amon is portrayed in human form holding the ankh in left hand and a ritual object in his right hand, possibly a knife, denoting his role as a protective agent.

SPHINXES

The Great Sphinx of Giza is one of the most curious of all the Egyptian monuments. It is 240 feet in length, 66 feet in height, with the body of a lion and a man's face wearing a royal 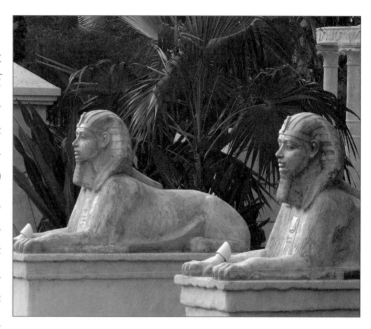 headdress. The Great Sphinx gazes enigmatically into the eastern horizon from a reclining position in front of and just to the south of the pyramid of Khafre. Its head and body are carved directly from the limestone formation and its paws consist of blocks of cut stone. Myths surrounding the Sphinx suggest it has mystical and oracular powers and poses a riddle to sincere seekers of knowledge. It is said that the secrets of the ages are revealed and bestowed upon those who successfully answer the Great Sphinx's riddle.

A no less spectacular tale from the Eighteenth Dynasty, inscribed on a stele situated between the paws of the monument, tells the story of a young man who became tired while

hunting and fell asleep in the shade of the great statue. The Sphinx spoke to the young man in a dream and requested that he clear away the desert sands that buried the creature up to its neck and threatened to choke him. In return, the Sphinx promised the royal throne to the man despite the fact he wasn't next in line to inherit it. After performing the challenging task of clearing away the sands, Thutmosis IV become pharaoh (1425 to 1417 B.C.).

Greek mythology similarly describes a sphinx-like creature with the body of a lion, wings of a bird and the face of a woman. It was a frightful creature that accosted travelers on the road and devoured those who could not answer this perplexing riddle: *What walks on four legs in the morning, on two legs at noon, and on three legs in the evening?* The answer is a human being who crawls on hands and legs as a baby, walks upright on two legs as an adult, and hobbles with a cane in old age. Oedipus, the son of the king and queen of the Greek city Thebes, was the first to successfully answer the riddle and upon doing so, the sphinx killed herself.

From ancient times unto the present, sphinxes appear throughout the world architecturally and as talismanic objects. Sphinxes most probably originated in ancient Egypt and were copied by the Greeks; however, they also appear in ancient cultures such as Assyria, Phoenicia and China. It's apparent from the rituals and mythology associated with each that they have a great deal in common despite varying location and style.

Although most sphinxes have the body of a lion, some have a human head while others have the head of a ram, falcon or lion. Additionally, some sphinxes have wings and tails.

In general, sphinxes are regarded as having protective qualities as well as the capacity to provoke good fortune and reveal mystical knowledge. The most prevalent today are the paired Chinese Lions commonly placed in the entryway of households and businesses. A Taoist ritual called the Hoi Gong ("Eye Opening Ceremony") is performed upon the lions to bless and imbue them with protective properties. A Taoist priest prays for the heavenly gates to open so that the lion's spirit may descend to earth and embody the lion's body. The lion is sprinkled with water for purification from a leaf from the Bu-Look or Pomolo tree. Then a symbol is placed on the lion's forehead to act as a mirror shield against evil spirits as it's believed the evil spirits will see their own reflections and be scared away.

Next, a ritual is performed to open the eyes and mouth of the lion. Small lights are placed inside the lion's eyes symbolizing spiritual radiance. Red paint is used to dot the lion's eyes in order to foresee good and evil. Finally, the lion is blessed. A red ribbon is tied around him as a symbol of courage and honor and as a reminder to do only good things. At this point, the lion is ready to awaken and come out of its den.[4]

The pharaoh in ancient Egypt was often portrayed in temple and tomb art as a lion capable of fearlessly devouring his enemies and protecting the sanctity of Egypt. Several of the most

[4] *http://www.pixi.com/~sgwserv/hoi-gong.html.*

artistically striking leonine sphinxes bear the images of Thutmoses III and **Hatshepsut**, both powerful pharaohs of the Eighteenth Dynasty. To date, the identity of the Great Sphinx is unknown, a riddle waiting to be solved like the Great Sphinx itself, although the most commonly held belief is that the Fourth Dynasty Pharaoh Khafre's face graces the unique monument.

Sphinxes bearing the likeness of the pharaoh could easily be misinterpreted to merely suggest that the pharaoh was a powerful ruler; however, it is more probable that only those pharaohs who knew the deeper riddle of the Sphinx and had achieved self-mastery were entitled to use its image. It is well known that the ancient Egyptian priesthood was skilled in the use of martial arts such as qigong and yoga. Postures assumed within these arts often mimic the natural movements of animals such as the yogic Lion Pose, also known as *Simhasana*. The *Simhasana* pose is generally performed in preparation for the *Three Bandhas*, special yogic postures known as "locks" that conserve and utilize vast reserves of energy, called **qi**, generated through advanced breathing techniques. We know from ancient Egyptian texts such as the **Book of Gates** (or "Book of Locks") and the **Book of Breathings** that such knowledge was of vital interest and importance to the ancient Egyptians.

But not all Egyptian sphinxes are leonine. The temple causeway at Karnak, for instance, is lined with an avenue of ram headed sphinxes. Of what significance is this, if any?

In order to answer this question, it's necessary to relate back

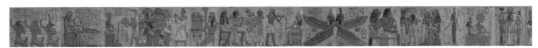

to the place where the "secrets of the ages" are housed, the Great Sphinx himself. Remembering that the Sphinx's gaze is oriented to the eastern horizon helps unravel a tiny bit of the riddle. Not only does the Sphinx face east, it is *precisely* oriented to the exact point of sunrise on the day of the spring equinox. By studying the motion of the stars and the sun, the ancient Egyptian astronomer-priests were able to predict and make use of certain cyclical events. They had extensive knowledge and understanding of the greater calendrical cosmic cycles such as the precession of the equinoxes caused by the wobble of the earth's axis. The precession results in the twelve ages of the zodiac (i.e., Aquarius, Pisces, Aries, etc.), each 2,160 years in duration for a total of 25,920 years collectively. This 25,920-year cycle is known as The Great Year.

In turn, the Great Pyramid is positioned precisely one-third of the way between the equator and the north pole and aligned to within 3/60th of a degree to true north-south. This alignment is more precise than that of the Meridian Building of the Greenwich Observatory in London, according to Robert Bauval and Graham Hancock, authors of *The Message of the Sphinx*.[5] Furthermore, the authors believe and have good evidence to support their theory that the three large Giza pyramids are positioned in mirror relationship to three stars in the Belt of Orion. There is no question that the Giza plateau served as an extraordinary astronomical observatory.

Noting the Egyptians' preoccupation with symbolism in art and

[5] Hancock and Bauval, *The Message of the Sphinx*, 60.

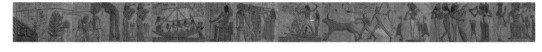

architecture, ram-headed sphinxes may have symbolized certain astrological qualities and/or a cycle of time oriented to Aries, the Ram, whereas leonine sphinxes may have referred to the astrological qualities and/or a cycle of time oriented to Leo, the Lion.

Taking this into consideration, what *is* the true message of the Great Sphinx?

Like all things Egyptian, the Sphinx's message presents itself on more than one level. On a first level, it serves as guardian and sentinel to the Great Pyramid, the House of Eternal Light. On a second level, it serves as a measurer of time and cosmic directional marker. However, to reveal its third level might deny you the opportunity to solve the riddle yourself and receive the Sphinx's gift of the "secrets of the ages"; however, it is possible that the enigmatic Sphinx can help point us in the right direction.

In many cultures, self-mastery is often symbolized in art with the portrayal of a human (male or female) or a deity such as a buddha or a saint sitting on, or placing one foot on top of, a feline animal such as a lion, tiger, leopard or jaguar. This symbolically represents reconciliation between "higher consciousness" and "animal instinct" of oneself, or on the larger macrocosmic scale, between "heaven" and "earth." The Egyptian leonine sphinx symbolizes this same concept of unification between the perfected human higher self and the animal-like lower self as well as the mystic marriage between heaven and earth. The ancient Egyptians believed that when a person achieved this type of

[6] Hancock and Bauval, *The Message of the Sphinx*, 207.

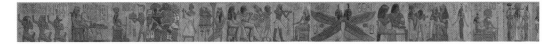

unification, he or she became **akhu**, meaning "Shining One," "Star Person" or "Venerable."[6] A star is merely a "living sun" that illuminates both heaven and earth. Perhaps it is for this very reason that the ancient Egyptians placed emphasis on observing earth's own living star, the sun, as it rises into the heavens in the eastern horizon on the morning of the vernal equinox, serving as a symbolic reminder to each and every one of us to rise to our highest potential and radiate our infinite brilliance!

THOTH OPENING THE GATES

All arts and sciences, writing, mathematics, medicine, magic, astronomy and astrology were accredited to, and placed in written form by, **Thoth,** the Egyptian god of wisdom according to ancient Egyptian mythology. Portrayed as a man with the head of an ibis, Thoth is frequently depicted in the pose of a scribe with writing palette and reed-pen in hand recording events such as the final judgment where the deceased's heart is weighed on the scales of balance against the feather of truth.

Known as Hermes in ancient Greece, the books of Thoth were studied and expounded upon by some of the world's

greatest philosophers. According to ancient Egyptian texts, one of the books authored by Thoth is the *Book of Coming Forth by Day,* still in print today under the more common title, the *Egyptian Book of the Dead.* This book is a collection of hymns, prayers and magical formulas that have been erroneously perceived to serve solely as a guide to the deceased for successful navigation through the underworld and into the heavenly spheres. In fact, the book is cleverly written in symbolism as a tool to elevate consciousness for purposeful living both prior *and* subsequent to death and alludes to an alternative to death itself. With advances in science, medicine, genetics and mysticism, this premise may not be as far-fetched today as it was only fifteen to twenty years ago. Regardless of the sensational claims contained within some of these ancient texts, or whether these claims can be considered literally, there is no dispute that these writings have inspired, intrigued, educated and touched the lives of countless minds over the course of thousands of years. And, in fact, this is the dream of *every* author and publisher— to inspire, educate and touch the lives of its readers, elevating consciousness for purposeful living.

As a symbol of inspiration and education, two life-sized figurines in bas relief of Thoth, the ibis-headed god of wisdom, are strategically situated on the double-doors leading from Reading Etc. into the facilities of Health Communications, Inc. These images are reproduced from Spell 161 of the *Egyptian Book of the Dead* and portray Thoth ("wisdom") opening the

portals, or gates, that lead to higher consciousness (see Fig. 40).

Rarely do we take into account the many people, materials, processes and time necessary to produce a single book. Just as skilled craftsmen and women of yesteryear painstakingly manufactured papyrus and ink pigments while schooled scribes diligently recorded the inventory of the royal palace, historical events, heartfelt hymns and poems, and lofty philosophical and spiritual musings, many helping hands within Health Communications, Inc. participated in the publication of this book to edit, design, print, bind, publicize and distribute it, each person an integral part of the whole, utilizing personal skill and wisdom to achieve the final result. This book, in turn, is only one of a vast number of resources published by Health Communications on life issues, recovery, self-help and personal growth, all reading tools that, in the tradition of Thoth, inspire, motivate, educate and touch the lives of its readers to effect purposeful living and elevated consciousness. Or in the words of Sir Francis Bacon (1561 to 1626), "Reading maketh a full man, conference a ready man, and writing an exact man."

THANKS TO THE READING ETC.
CREATIVE TEAM

The development of Reading Etc. reminds me that everything worthwhile we accomplish in life requires both individual effort and teamwork. The companies and individuals listed here turned an idea into reality. Many went beyond the call of duty, challenged some of their preconceptions and expanded their horizons. I hope each person felt a renewed sense of accomplishment and had some fun along the way. I also hope they feel as much pride in seeing what they helped to create as I do.

And, to my talented, creative staff at Health Communications, I can't thank you enough for the work you do, your support and energy. Each one of you is a gift that has helped make our company unique and successful. I couldn't, and wouldn't, do it without you.

Peter Vegso

President, Health Communications, Inc.
Proprietor, Reading Etc.

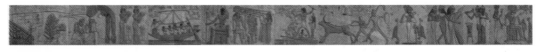

ANTES DE CRISTO

Daniel Quiroz and Adriana Rojas, Artisans

Daniel Quiroz remembers what his father said to him one day: "Give your materials what they ask from you." Since Egyptian art dates back many centuries, age, character and strength are exactly what the materials needed.

"Conceived on paper," Quiroz explains, "experts say a plan should reflect the final outcome of a project. Revising the original drawings with Norberto Grundland, I understood what he felt. In this case, what was drafted on those drawings could not reflect the final result of this project, because paper misses something marvelous, which we as human beings possess—feelings! Only through feelings can you give personality to your work."

When Quiroz noticed this, he learned that the most valuable asset is not the materials used, or the drawings fixed on a plan, but the melding of all of these elements with the human beings' capacity to transform an idea into reality.

THE PANELS

The technique used to duplicate the reliefs is very similar to that used by the ancient Egyptians. Due to the time factor, Quiroz saw the need to change

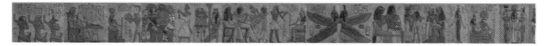

some of the materials in the developmental stage. He found a perfect ally in clay. Basic outlines of the relief were done over a flexible mold for the purpose of reproduction. The team worked in the way and in quantities almost identical to the ones used by ancient artisans. Once completed and detailed, they had a master mold proof in plaster, and then produced a positive (identical to the one made of clay). The advantage of using plaster is that it is a flexible material that allows reproduction of grooves and cracks, which suggest a natural erosion or aged look.

With great emphasis on seams from one panel to another, the team finally worked on the production of a final mold, which was made of polyester resin, fiberglass and polyurethane mixed with sand bits. Once they reached this stage they were ready to begin an "alchemic process," in which materials compatible in appearance to one another are melted into one.

The final touch was given by the patina, mainly composed of local powdered stones whose object was to maintain the stability of the tones and make the grooves and textures stand out. "The patina is definitely the touch that gives personality and individuality to each panel or molding, and bonds all that is involved in the creative and emotional process we call art," explains Quiroz.

SPECIAL THANKS FROM DANIEL QUIROZ

First and foremost, I would like to thank Adriana, my partner, friend and wife. All of us who work at Antes de Cristo know the company is the way it is and has such a great appeal thanks to her strength and support. Even if Adriana is tired and stressed, she picks herself up and sets the example and gives us that second wind

to do what we need to do. I love you and I want to tell you that you are the Soul of Antes de Cristo.

Chato—For that special touch you have to let go in those difficult moments and firmly grip the soft ones, and for your talent to produce finishes.

Leon—When I met you, I knew that you were the most noble and loyal man with whom I have ever worked.

Lupe—You can pass as being part of my family, which is why you seem so precisely familiar.

Jorge Vargas Palomera—Few times in my life have I had the great luck to meet a truly, talented artist, a great mentor. The pride and honor I feel for you will be with me now and forever. Jorge, you are the best sculptor I have ever met. Congratulations.

MANUFACTURING BY SKEMA, INC.
Norberto Grundland, Design Consultant

Born in Argentina, Mr. Grundland was raised in Italy, and attained a degree in architecture. He has had the opportunity of living in many countries before arriving in the United States in the early eighties.

In 1988, he founded Manufacturing by Skema, Inc., located in Davie, Florida. The company designs and manufactures handcrafted furniture with a specialty in custom cabinetry for residential and commercial applications. Manufacturing by Skema's factory of twenty employees caters to both local and international clientele.

Mr. Grundland recalls the day when Theresa Peluso at Health Communications, called the studio and said, "'Mr. Vegso thinks you are our man.'"

He continues, "I realize today, standing at Reading Etc., in front of mouldings, friezes and sculptures, how far from the truth that statement was. I am only part of a team, that through the vision of Peter Vegso, the research of Melissa Applegate and the devoted coordination of Ms. Peluso, have been able to translate conceptual drawings into works of art. A challenging task brought to reality thanks to the craftsmanship of companies from different countries, a rewarding finale to an international blend of materials and techniques."

BORACCI BUILDERS, INC.
Walter Boracci, President;
Hugh Haines, Vice President

Since 1988, Walter and Hugh have been involved in the development of more than 100,000 square feet of Health Communications' corporate headquarters. After having completed the most recent expansion of HCI's manufacturing facility, they were asked, almost as an afterthought, if they'd be interested in remodeling 2,500 square feet within the facility. That project, Reading Etc., turned into one of the more challenging and unconventional jobs in the firm's portfolio. Building by design, with decisions made as each stage was developed, required assembling a talented group of tradesmen to meet the challenge.

After working for a large commercial developer during the South Florida real estate boom of the '70s and '80s, Walter and Hugh founded Boracci Builders, Inc., in 1990. Walter is a native of Long Island, New York, and a graduate of The University of Miami, while Hugh hails from Jamestown, Ohio, and graduated from Bowling Green State University.

Walter, his wife Sue, and son Nicholas reside in Broward County, while Hugh, his wife Kim, and daughters Brittany and Carly call Palm Beach County home.

CHRISTENSEN WOODWORKS
Ronald B. Christensen, Master Cabinetmaker;
Alicia Mira Christensen, Design Consultant

Ron has been working with wood professionally since the mid-1980s after attending Tennessee Technological Institute and obtaining his BFA in furniture design. Alicia holds a degree in textile design and environmental/product design from Rochester Institute of Technology.

Their pieces have been exhibited nationally and have appeared in the book, *High Touch*, published by EP Dutton, as well as featured in numerous publications including *Fine Woodworking Magazine*, *Furniture Today*, *Interior Design Magazine*, *New York Talk* and *Florida Home and Garden Resources*. Their work has been commissioned by some of South Florida's most prominent residents and is known by designers and architects around the country.

The craftsmanship and beauty of the cabinetry they designed for Reading Etc. enhances the ambiance of the showroom and perfectly compliments the products displayed within.

Ron and Alicia are residents of Boca Raton, Florida.

Michael Mahon, Plasterer

A native of Dublin, Ireland, where he was educated at Terenure College, Michael joined the family plastering business at an early age. After learning the business from the ground up, he developed an affinity for restoration of historic Georgian buildings with their specialized plasterwork.

Now making his home in the United States, Michael designs and constructs built-in wall and entertainment units with plaster finishes and is still lending his craftsmanship to restoring some of Florida's older, historic buildings. His most recent contribution to the preservation was the plaster restoration of the Old Deerfield Beach Schoolhouse.

When we decided to replicate an ancient stone facade as the exterior finish for Reading Etc., the luck of the Irish was with him, as Michael enjoys the creative challenges of developing unusual plaster finishes.

Michael lives in Boca Raton with his wife, Shiela, and two sons, Michael Jr. and Liam.

WONDERFAUX WALLS
Kenneth Salowe, President

Founded in 1984, Wonderfaux Walls specializes in the art of surface finishing. Continuously experimenting with new and different techniques ranging from contemporary to traditional applications, Ken and his team of artists never stop learning and improving the process. The range of their work spans wall glazing and *trompe l'oeil*, to boiserie restoration and stucco veneziano.

Ken studied architecture for five years in Florida and Washington, D.C., and trained at the Parsons School of Design in Paris. He also completed the Day Studio Workshop in San Francisco. His commissions have included work throughout the United States, Central America and the Middle East.

The soft patina of the wall glazing in Reading Etc., and the whimsical *trompe l'oeil* of ancient Egyptian symbols were the finishing touches needed to make the showroom complete.

Ken resides in Broward County with his wife, Lori, and son, Julian.

Joe Dzwill, Artist

While Joseph Dzwill took a circuitous route to find his calling, he eventually realized what his heart and soul always knew: He was meant to be an artist. He recalls that as a boy growing up in New York, his parents presented him with a model car as a gift. As any enthusiastic boy would, he ripped open the box; however, his frenzied anticipation wasn't so that he could play with the car, but so that he could use the box as a canvas upon which he painted the family's blue Ford. Dzwill still considers any surface an appropriate canvas. His portfolio boasts custom murals adorning the walls of upscale homes, elaborate scenes painted on motorcycles, masterfully crafted canvases and stone sculptures. Most recently, he painted two scenes on the ceiling of Reading Etc.—a mural of birds in flight and the Egyptian Zodiac.

"Each time I begin a job, I pray for guidance because I want people to enjoy what I do," Dzwill says. While he didn't have a background in Egyptian art, per se, he says that prior knowledge wasn't necessary since a true artist can sense a culture or a style through the sheer process of creating. "I believe that all artistic souls are connected. They are connected across nations, across time, across the universe," he says. "Sometimes people see my work and ask me, 'Did you study Cezanne?' when I haven't studied his particular style. Artists change styles as they learn and as they grow, which is what happened while doing the Reading Etc. project," he explains. "When I was painting the intricate calligraphy letters on the zodiac, at one point, it was if I wasn't

copying the image but free-writing and understanding what I was painting."

His biggest challenge during the project was to stay consistent with the other artwork, which was painted and shipped from around the globe, and ensuring that his artwork was not too light or too overpowering against all of the other elements in the room. He attended the Fashion Institute of Technology in Manhattan, where he studied advertising with some classes in life drawing, and attended the Arts Student League, a group of artists that hosted such notables as Andy Warhol.

At the age of thirty-five, he realized that he should spend his life doing what he was born gifted to do. At the same time, one his friends noticed Dzwill's portfolio at an art show and was impressed with his versatility. His friend, Ken (the owner of Wonderfaux Walls), asked Dzwill to be one of the main artists for his design business. So, Dzwill began commuting from New York to Florida, painting custom murals for homes in the area. He soon learned that this could become a full-time vocation and moved with his family to South Florida a short time later.

TOPIS FACTORY
Lilyan Benecke, Ceramic Artist

Lilyan Benecke, artist, designer and woman of many talents, began her love affair with tiles many years ago. Having worked as an interior designer and ceramic artist, Lilyan decided that none of the tiles available to her had the warmth of character or richness of tradition that she wanted in her own home. As she worked to produce her own tiles, inspirations from her design studies in England and her ceramics training in China emerged to the surface. As friends visited her home and studio and saw Lilyan's work, orders came pouring in. Her factory grew from the home studio to the present-day TOPIS factory, employing more than twenty-five tile makers.

Today, Lilyan's factory is still in the developmental stages and continues to grow and evolve to meet the demand for its tiles. The TOPIS factory is well known for finely crafted tiles and also for beautiful handmade painted accessories that are sold in the finest Guatemalan stores. The factory has been exporting to the United States since 1990 to many exclusive clients.

GLOSSARY

ab - A component of the heart associated with its higher spiritual nature and connected with the hati, the lower or instinctual aspect of the heart. In turn, the ab and hati are inexorably linked with the ba and ka respectively.

Abydos - One of the chief religious centers dating to predynastic Egypt and identified with Osiris, the neter of death and resurrection. It is comprised of numerous cemeteries as well as the temples of Osiris, Seti I and Ramses II, among others. It was every Egyptian's goal at least once in a lifetime to make a holy pilgrimage to this important spiritual site. In some eras, public plays called the "Mysteries of Osiris" were performed at Abydos that enacted Osiris's death and subsequent resurrection.

Akhenaton (Amenhotep IV) - Eighteenth Dynasty pharaoh who ruled from approximately 1353 to 1335 B.C. He abandoned the existing religious views of the Amon priesthood, banned the Egyptian pantheon, and obliterated art and monuments portraying the old religion in favor of a sole deity, Aton, who manifested in the form of the sun disk. Amenhotep IV subsequently changed his name from Amenhotep to akhen-Aton, meaning "pleasing to Aton." Akhenaton and his favorite queen, Nefertiti, produced six daughters and no sons. He was succeeded upon his death by Tutankhamon, probably the child of Kiya, a lesser wife. It's speculated that Akhenaton's early demise may be attributed to murder due to his widely unpopular religious and political views.

akhu - (lit. "Shining One," "Star Person" or "Venerable") An "imperishable star" used in reference to the enlightened initiate or deceased who achieves victory in the Double Hall of Ma'at (Truth).

alchemy - The science of transforming base metal into silver or gold; the mystical practice of transforming the undeveloped student or initiate into an "illumined" being.

Ammit - A monstrous hybrid creature, part lion, hippopotamus and crocodile, frequently portrayed positioned beside the Scales of Justice in the Double Hall of Truth waiting to devour the impurities of the heart of the deceased or initiate during the "Weighing of the Heart" ceremony.

Amon (also Amun, Amen) - A neter associated with creation, popular in the city of Thebes, whose name means "Hidden One." Worship of this neter remained steady until interrupted by the brief reign of Pharaoh Akhenaton who banned the existing pantheon in favor of one deity, Aton. Amon worship was restored upon Akenaton's death by the successor to the throne, the young boy-king Tutankhamon.

ankh - A hand-held ritual instrument used to perform the "opening of the mouth" ceremony on the living pharaoh and the deceased resulting in the "breath of life." It is the most prolific symbol found in ancient Egyptian art and is equated with long or eternal life.

Anubis - A neter portrayed with a human masculine body and jackal's head associated with embalming and mummification. Anubis was the illegitimate son of Nephthys and Osiris, born as a result of Nephthys's deceptive seduction of her sister's husband, Osiris. Anubis assisted at the "Weighing of the Heart" ceremony, guiding the deceased or initiate into the Double Hall of Truth and checking the balance on the Scales of Justice.

Apep - A large serpent residing in the celestial waters that attempted to thwart the sun Ra on his nightly passage through the underworld.

Apis - The body of a bull assumed by the neter Ptah symbolizing masculine generative force. An Apis bull had to be black with specific markings such as a white triangle on its forehead and a knot in the shape of a scarab beneath its tongue. It was primarily associated with the cult center of Memphis and publicly displayed during festivals. It was mummified upon its death whereupon the search for a new Apis bull began.

atef - A white royal crown of Upper Egypt adorned with two ostrich plumes and associated with the neter Osiris.

Aton - The neter associated with the sun disk and worshipped by the Eighteenth Dynasty Pharaoh Amenhotep IV who changed his name to akhen-Aton in Aton's honor.

Atum - A neter of primordial light worshipped in the city of Heliopolis who was believed to have

emerged from the dark and watery abyss of Nun by an act of self-awareness. Like the atom, Atum was considered the building block of all physical matter and the father of fundamental neteroo (or forces) known as the Divine Ennead.

ba - The collective soul of an entity often depicted in Egyptian art as a human-headed bird. It is the totality of the various incarnations and personalities of a being and can freely express itself in the non-material world as well as the material world by manifesting in any form it chooses. It is often associated with the deceased human soul; however, adepts such as some shamans, martial artists and lamas may also manifest ba bodies while living. Neteroo were also known to manifest ba bodies such as the Apis bull of Ptah.

Barque of Millions of Years - The solar boat navigated by the sun neter Ra that descended into the underworld each evening and rose each subsequent morning. The deceased hoped to gain entry onto the barque in order to become a shining sun like Ra and rise from the dead.

Belt of Isis (Knot of Isis, tiet) - A belt or girdle tied in a knot around the waist to secure a garment. Also a funerary talisman similarly shaped associated with rebirth and the feminine generative organs often made from carnelian, red glass or other crystalline substances.

ben ben - An obelisk or conical shaped object representing the first ray of light that touched the earth, dispelling the dark chaos of Nun. A ben ben, possibly of meteoritic substance, was enshrined in the ancient cult city of Heliopolis.

bennu - A large blue heron or phoenix believed to greet the deceased upon entering the heavenly realms symbolizing rebirth. The large bird is mythically associated with the ben ben and first appeared upon the primordial mound that arose from the chaotic waters of Nun.

bija - The energetic potential behind physical manifestation; seed syllables of sound that emanate from the chakras. Bija corresponding with the main chakras are as follows: root chakra - lam; sacral chakra - vam; solar plexus chakra - ram; heart chakra - yam; throat chakra - ham; brow chakra - om; and crown chakra - sat nam.

Book of Amduat (Book of That Which Is in the Duat) - Ancient Egyptian text discovered inscribed on tomb walls in the Middle Kingdom describing twelve divisions (or hours of the night) in the duat, a dark tunnel through which the deceased or initiate traveled before entering the heavenly realms.

Book of Breathings - A condensed and revamped version of the *Book of Coming Forth by Day* compiled in the Eighteenth Dynasty. This book was considered so important that the pharaoh was often portrayed carrying this scroll in hand and a copy of it was placed either in hand or near the heart of the deceased.

Book of Coming Forth by Day - A compilation of spells, prayers and hymns from coffin and pyramid texts used by the deceased for successful ascension into the heavenly realms and by the initiate for successful raising of consciousness to a state of "heavenly bliss" or enlightenment.

Book of the Dead - see *Book of Coming Forth by Day*.

Book of Gates - Ancient Egyptian text discovered in late Eighteenth Dynasty tombs that more fully elaborates the gates or divisions of the duat described in earlier renditions of the *Book of Amduat*.

caduceus - A slender staff adopted as the emblem of the medical profession adorned with two upraised, intertwined snakes. The Egyptian neter of wisdom, Thoth, is often portrayed with caduceus in hand as he was believed by the ancient Egyptians to be the originator of all medical knowledge. The mystical implication of the caduceus is associated with kundalini energy that lies dormant at the base of the spine like a sleeping serpent and rises when awakened through yogic practice. As the kundalini rises, it passes through meridians on either side of the spine and intersects at points along the spine corresponding to the major chakras.

canopic jars - Separate containers in which the embalmed lungs, liver, intestines and stomach of the deceased were preserved.

chakras - Vortices shaped like wheels or lotus blossoms with varying numbers of petals through which subtle energy is distributed throughout the body. Seven major chakras are aligned with the spinal column in the following positions: at the base of the spine, approximately two inches below the navel, at the solar plexus, heart, throat, brow and crown.

crook and flail - Instruments associated with the pharaoh symbolizing the authority to compassionately aid or strictly discipline his or her contingency.

Divine Ennead - The primary or fundamental forces that result in the creation of life and all forms of matter. The ennead consists of four pairs of polarized principles plus the Divine or a total of nine neteroo. Different enneads were associated with various cult centers over the course of time but the most famous was the great ennead of Heliopolis comprised of Atum, Shu and Tefnut, Geb and Nut, Osiris and Isis, Set and Nephthys.

djed - A pillar-shaped object symbolically associated with Osiris, the male reproductive organ, the spinal column and the Tree of Life. Its origin may have derived from the myth in which Set murdered Osiris and threw the corpse into the Nile River where it washed ashore and became embedded in a Tamarisk tree. Osiris's wife Isis retrieved the body from the tree and restored it to life through mystical means. A djed was ceremonially raised at the Heb-Sed to symbolize the potency and duration of the pharaoh's rule.

Double Hall of Ma'at (Truth) - A great hall in which the deceased or initiate was escorted in order to be judged by forty-two assessors by virtue of the Negative Confession and Weighing of the Heart. If successful, the deceased or initiate was considered "true of voice" and "justified."

duat - River of stars upon which the deceased soul or initiate sailed into the heavens via a solar barge. The Nile River was thought to be a mirror image of the duat.

Flower of Life - A geometric symbol found in the Osirian at Abydos in Egypt and various temples worldwide that contains the codes of creation, specifically, the five Platonic Solids of which all matter originates.

Four Sons of Horus - Neteroo in charge of protecting the organs of the deceased or initiate while undergoing the trials and tribulations of the duat. Imsety protected the liver, Hapy the lungs, Duamutef the stomach and Qebhsenuef the intestines.

Geb - A neter symbolizing the earth, married to the sky Nut and separated by the air, Shu.

Hall of Ma'at (Truth) - see Double Hall of Ma'at.

Hapi - The neter associated with the Nile River and abundance, generally portrayed as a bearded man with blue skin and pendent breasts.

Hathor - A netert occasionally portrayed in the form of a cow, or a woman with the face of a cow, but more often Hathor is depicted as a woman wearing the horned solar disk crown. She is the personification of personal love, pleasure, music and dance. Hathor is generally regarded as the wife of Horus. In this capacity she acts as the protectorate of the queen whereby Horus serves as protectorate of the king. Cosmically, Hathor is associated with the west, the place where the sun sets and the dead are buried; however, she is also paradoxically associated with birth. The pharaoh and deceased are often shown suckling Hathor in the form of a cow symbolizing the nurturing aspects of the goddess.

hati - A component of the heart associated with its lower instinctual nature and connected with the

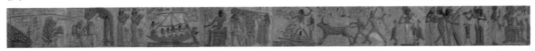

ab, the higher or spiritual aspect of the heart. In turn, the hati and ab are inexorably linked with the ka and ba, respectively.

Hatshepsut - Eighteenth Dynasty queen married to Thutmosis II until his death (1492 B.C. to 1479 B.C.). He was succeeded by a son, Thutmosis III, borne by a lesser wife. Hapshepsut acted as co-regent until the seventh year of Thutmosis III's rule when she assumed the dominant role and declared herself pharaoh by Divine declaration. She ruled for twenty-two years until her death whereupon Thutmosis III reclaimed the throne.

heb-sed - A jubilee held in the thirtieth year of the pharaoh's rule celebrating the pharaoh's successful rulership and the unification of Upper and Lower Egypt. A ritual run and other tests of endurance were performed by the pharaoh to ensure he was physically competent to rule.

henu - A culmination of a series of gestures in a ceremonial dance in which the performer kneels on one knee with arm extended and hand open while holding the other arm with closed fist crooked back toward the body. The extended arm is then drawn back, the fist is closed and the chest lightly struck with alternating blows from the closed fists, symbolizing renewal, power and compassion.

hieroglyphs - (Greek, "holy writings") A series of comprehensive pictographs that convey ideas and/or phonetically express the name of the object portrayed. The earliest known historical writings are hieroglyphic and were discovered in southern Egypt on ivory labels attached to bags of linen and oil in the tomb of King Scorpion I, carbon dated to 3300 B.C. to 3200 B.C.

hierophant - High priest of the ancient Egyptian priesthood who officiated at rites of initiation and served as abbot of the Mystery School.

Horus - Son of Osiris and Isis who avenged the murder of his father and exemplified the pharaoh by the restoration and maintenance of justice, law and order.

Horus of the Two Horizons - see Ra-Harakhte

Horus the Elder - One of the five children of Nut representing the five intercalary days celebrated before the Egyptian calendrical New Year. Nut was forbidden by the sun Ra to bear children during any given month; however, Thoth came to her rescue by winning a seventy-second part of the moon's light in a game of draughts. On each of these consecutive days, Nut gave birth resulting in five neteroo: Osiris, Isis, Horus the Elder, Set and Nephthys.

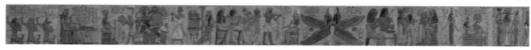

initiate - One who undergoes a test or formal rite of passage in order to prove and/or receive mystical knowledge and experience.

initiation - A test or formal rite of passage generally lasting a minimum of three days and three nights during which a candidate is provoked by spiritual or psychic means to prove his or her existing level of spiritual accomplishment and gain access to additional mystical skills or knowledge.

Isis - The netert of love and femininity expressed through various archetypal roles such as sister and wife of Osiris, mother of Horus, and queen of Egypt. She is adept in ruling elements of nature such as rain, able to command the seasons, produce fertile land and bring prosperity to the people. The name Isis means "seat" and her traditional headdress is shaped like a stepped throne, indicating her authority to rule and the power of love. At times she is also depicted wearing a headdress with the horns of a cow and a lunar disc. In this capacity, she expresses the ability to both nurture and transform matter since the cow is associated with milk and the moon with the unseen psyche. Subsequently, she is also recognized as the mistress of magic.

ka - The individuated soul, ego or personality of a human being portrayed by the ancient Egyptians hieroglyphically as a pair of arms upraised to the heavens.

Khepri - A neter portrayed with human body and scarab's head symbolizing the rising or morning sun. The name Khepri means "he who comes into existence" and "scarab." Scarabs were used as protective amulets by the ancient Egyptians and therefore Khepri was believed to ensure the soul's continuity after death.

khu - The collective soul or higher self of a human being that is illumined and radiates light equivalent to angelic presence or neteroo.

kundalini - Energy of a feminine polarity that collects at the base of the spine like a coiled serpent. As awareness develops, or by use of intentional breath exercises, the kundalini rises like a cobra up the spinal column. In ancient Egypt, the pharaoh wore a diadem with an upraised cobra to signify that his kundalini had risen.

lotus - A flower of the water lily family that was held sacred by the ancient Egyptians due to its triune nature: its roots grow in mud, its stem in water and its petals in air. The lotus was equated with the cyclical nature of death and birth due to the fact that it closes at night and opens with the first light of dawn.

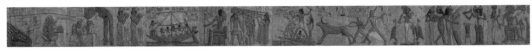

manna - Spiritual food such as the holy bread or wafers offered in religious ceremony, or the vital force derived from breath.

mastaba - Rectangular, mud-bricked tomb from the Old Kingdom with sloping sides constructed over a shaft leading into a chamber containing the mummy and funerary offerings.

Ma'at - A netert generally portrayed as a woman wearing a white ostrich feather headdress. The feather was placed on one side of the Scale of Justice and the heart of the initiate or deceased on the other side of the scale during the "Weighing of the Heart Ceremony" in the "Double Hall of Truth" or Ma'at. The pharaoh and all the other neteroo governed by principles of Ma'at, as it was Ma'at who presided over matters of truth, justice, law, balance and divine order. In some myths, Ma'at was portrayed as the wife of Thoth—the neter of wisdom—symbolizing the marriage between wisdom and truth.

menit - A necklace that may have been used ceremonially as a hand-held percussion instrument producing a rattling sound. It was associated with Hathor, the netert of personal love, birth and fertility, and believed to transmit the essence of the goddess to its recipient.

mummiform - In the form of a mummy, i.e., an embalmed and dried corpse wrapped in strips of linen.

nebu - A hieroglyph meaning "gold" drawn in the shape of a metal necklace or collar and/or sometimes as a footstool upon which a goddess kneels, often inscribed on the deceased's coffin or tomb symbolizing imperishability.

Nefertari - The first and favorite wife of Pharaoh Ramses II (1279 to 1213 B.C.) of the Nineteenth Dynasty whose titles include "for whom beauty pertains"; "god's wife"; "king's great wife"; "hereditary noble woman"; "mistress of the two lands"; "who satisfies the gods"; "for whom the sun shines"; "great of favors"; "lady of charm"; "sweet of love"; and "rich of praise."

Nefertum - A neter generally portrayed as a boy emerging into life from the center of a lotus flower or as a full-grown man wearing a lotus flower headdress. Nefertum was the son of Ptah and Sekhmet in the Memphite triad. The word "nefertum" means "lotus" and was regarded by the ancient Egyptians as a symbol of birth since the lotus was observed to close at night and bloom the following morning.

Neith (also Net, Nit) - One of the oldest of the neteroo, sometimes considered the personification of Nun, or that which existed before creation. She was regarded as a protector deity and was generally depicted as a woman wearing a weaving shuttle headdress or, in the alternative, crossed arrows and

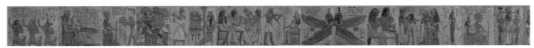

shield. During the great debate between Set and Horus as to who should rule Egypt (symbolizing "evil" and "good" respectively), Neith was called upon by the other neteroo to arbitrate. She ruled that the throne should be awarded to Horus and Set should receive compensation in the form of twice his existing property plus two more wives. One of the most widely recognized representations of her is as one of the four golden tutelary goddess statuettes guarding the sarcophagus of Pharaoh Tutankhamon.

Nekhebet - The vulture goddess associated with Upper Egypt, often portrayed wearing the white crown. She was frequently shown in conjunction with Wadjet, the cobra goddess, associated with Lower Egypt, symbolizing the unification of the two lands.

Nephthys - A netert whose name means "Lady of the House." Nephthys was both wife and sister of the evil neter Set, symbolizing the attracting and repelling forces of magnetism, and sibling to Isis, Osiris and Horus the Elder. She was one of four offspring produced by Nut (the sky) and Geb (the Earth). Nephthys produced one child, Anubis, subsequent to deceiving and seducing her sister Isis's husband, Osiris, by getting him drunk. After Set murdered Osiris, Nephthys helped Isis collect and reconstitute the body parts. She is one of four tutelary goddesses together with Neith, Selket and Isis, whose role is to protect the lungs of the deceased or initiate.

neter/netert/neteroo - Archetypal principles such as wind, moisture, earth, sky, death, birth, love, evil, etc., that are portrayed in Egyptian cosmology as gods and goddesses, animals, plants, or a combination of these elements. Neter expresses the masculine gender (i.e, the neter Thoth), netert the feminine gender (i.e., the netert Isis) and neteroo plural (more than one).

Nun - The primordial soup or chaos out of which all matter emerged, beginning with the neter Atum. Nun was referred to by the Egyptians as "Infinity," "Nothingness" and "Nowhere," among other names.

Nut - A netert symbolizing the sky generally portrayed as a woman with an elongated body spanning the horizons. Although separated from her husband, Geb, the earth (often shown in ithyphallic form) by Shu, the air, during the day, Nut descended to Geb in the evening. Forbidden to marry in any given month of the year, Nut and Geb produced five offspring—Osiris, Horus the Elder, Set, Isis and Nephthys—during five intercalary days before the New Year won in a game of draughts by Thoth, the god of wisdom.

obelisk - A tall, tapering four-sided shaft of stone with a pyramidal apex.

Opening of the Mouth - A ceremony performed on the pharaoh, statuary or mummy by lightly striking the mouth with an iron instrument or touching the lips with an ankh. In the case of the pharaoh or statuary, the ceremony was performed for oracular purposes in order to facilitate Divine Utterance so that the word of the gods could be heard. The ceremony was also performed on the mummy from the Middle Kingdom, in order to assist the deceased to speak the proper spells and incantations necessary for continuance of the soul into the afterlife.

Osiris - A neter generally portrayed in mummiform with plumed headdress, holding the crook and flail, instruments associated with the pharaoh. Osiris was husband to Isis, the netert of love, and one of the five siblings of Nut and Geb, along with Set, Nephthys, Isis and Horus the Elder. He was murdered in a jealous rage by Set and his body was cut into fourteen pieces. Osiris was eventually resurrected through mystical means with the assistance of his wife, Isis, and subsequently every deceased entity was referred to as "Osiris" in the hope of ultimate resurrection. It was every Egyptian's once-in-a-lifetime goal to make a pilgrimage to the holy site of Abydos dedicated to Osiris. Osiris was also called upon by the Egyptians for the success of their crops as it was believed he had the power to create new growth from infertile and arid soil. Thus, in addition to death, he was also associated with birth. His skin was often painted green, symbolizing the regenerative aspect that plants undergo as they lay dormant in winter and bloom in spring.

papyrus (*plural* **papyri**) - Paper made from papyrus plants that grew along the banks of the Nile. Papyrus is made by placing strips of the inner pith of the plant stem side-by-side and overlapping on top of a piece of cloth placed on a hard, flat surface. Additional strips are placed on top of and at right angles to the first layer and covered with a second piece of cloth. The pith is then beaten with a mallet or flat rock that causes a starchy glue to exude and bind the flattened plant fibers together. The cloth is then removed and the paper placed in the sun to dry. The paper may be polished by rubbing it with a smooth stone.

pharaoh - The king who was believed to be Divinely appointed to rule and act as an intermediary between the people and the gods. He was referred to as "the good god."

primordial mound - The first land to appear out of the primordial sea at the time of creation. Pyramids and certain temples and tombs were often architecturally designed to visually represent the primordial mound.

Ptah - The neter known as the "Divine Architect of the Universe" whose tongue uttered the name of everything and caused it to come into existence. Ptah was especially revered in Memphis, the oldest

city of dynastic Egypt, and referred to as the "Greatest of Craftsmen." Architects, engineers, stonemasons, metalworkers, shipbuilders and artists showed particular favor for this neter into the late dynasties. He was often associated with the Apis bull denoting virility, stamina and fertility.

pyramid - A solid structure with a square base and four triangular sides that slope and meet in a point, used in ancient Egypt as vehicles of transcendence for the deceased and the initiate; the word pyramid meaning "fire in the middle" and symbolic of the eternal flame generated through yogic breath work in the physical human body.

qi - A force generated by the sun and circulated through the body and all living things via the breath. Qi is thought to have health enhancing attributes and therefore is intentionally cultivated through specific exercises by yogis and martial artists.

Ra - The neter associated with the sun, generally portrayed as a hawk-headed man wearing a sun disk encircled by a cobra that spit at his enemies. The Egyptians poetically conceptualized the sun's passage from horizon to horizon as Ra sailing through the body of Nut, or the sky, in a solar barge. Ra descended into the underworld at sunset where the huge serpent Apep attempted to thwart his daily passage; however, Ra was always victorious, rising the following morning.

Ra-Harakhte - The dualistic aspect of Ra, "Harakhte" meaning "Horus of the Two Horizons."

Ramses I - Pharaoh from 1320 to 1318 B.C., founder of the Nineteenth Dynasty, father to Seti I and grandfather to Ramses II. Ramses I was awarded the throne by the former pharaoh, Horemheb, who was childless.

Ramses II - Pharaoh from 1279 to 1212 B.C., the third ruler of the Nineteenth Dynasty who became known as "Ramses the Great." The son of Seti I, Ramses lived to be 90 years of age, fathered 162 known children, and left an impressive legacy of architectural temples such as Abu Simbel, the Great Hypostle Hall of Amon at Karnak and the mortuary temple at Thebes known as the Ramsesseum. He went into lengthy battle against the Hittites to reclaim Egyptian land, neither side conclusively winning a victory. Subsequently, a treaty was signed and the lands divided. As part of the treaty, Ramses agreed to marry the daughter of the Hittite king.

samtaui - A ritual gesture symbolizing the union of Upper and Lower Egypt; it included binding the plants of the north and the south around an emblem of union.

sarcophagus - A decorated coffin or chest in which the mummified remains of the deceased were housed.

scarab - A beetle revered by the ancient Egyptians often replicated in jewelry pieces and talismans for its protective attributes. The Egyptians observed the scarab rolled a ball of dung in front of itself and then buried it in the ground. The ball of dung seemingly metamorphosed from larvae to pupa and a new scarab emerged. The Egyptians noted that the scarab rolling the dung ball mimicked the sun's daily movement across the sky; its burial beneath the earth imitated the sun's setting and the emergence of the new scarab from the ball of dung duplicated the sun's rising and self-generation.

Selket (also Serquet) - One of four tutelary goddesses, together with Neith, Nephthys and Isis, whose role is to protect the intestines of the deceased or initiate. She is generally portrayed as a woman wearing a scorpion headdress or as a woman with a scorpion's head. She was called upon to protect against the bites of venomous snakes and insects common in Egypt and to transmute negativity.

senet - A popular board game played by the ancient Egyptians. The board had thirty squares upon which flat and conical pieces were moved.

Serapeum - An extensive subterranean gallery containing the sarcophagi of twenty-four Apis bulls buried in single blocks of granite weighing between sixty to eighty tons each discovered by the French archaelogist Auguste Eduard Mariette in 1851 A.D. at the ruins of Saqqara near Memphis.

Set - The neter associated with evil generally portrayed with a male body and the head of a typhon, a strange creature with a long curving snout, rectangular upright ears and tufted tail. In the alternative, he was described with red eyes and red hair and as having torn himself from his mother Nut's womb and bursting through her side. Some of the most famous Egyptian myths portray Set in an adversarial role in which "good" ultimately prevails.

Seti I - Pharaoh of the Nineteenth Dynasty from 1314 to 1304 B.C., the father of Ramses II, renowned for the architectural and artistic sophistication of the temple erected at Abydos as well as his own tomb. Seti installed Ramses as prince regent while only in his mid-teens. Seti protected the Egyptian border against the Libyans and expanded territory into Syria and Palestine.

shen - A symbol meaning eternity and evoking protection. It was often replicated in jewelry such as the shen ring and its design incorporated into the cartouche which encircled and protected the king's name.

Shesat - The netert of wisdom, wife of Thoth, generally portrayed as a woman with a star headdress. She was regarded as a celestial librarian and patroness of arithmetic, architecture and records. Shesat recorded the duration of the pharaoh's life on a knotched palm branch having calculated the length of his days and the results of the actions (karma) of the deceased or initiate on the leaves of the Tree of Life.

shesheset - see sistrum.

Shu - The neter of air, wind and atmosphere, "shu" meaning "to be empty." He was often portrayed as a lion or sometimes as a bearded man standing or kneeling over Geb (the earth) with his hands raised supporting Nut (the sky). Shu was married to his twin sister, Tefnut (moisture).

sistrum - A musical instrument made of wood or metal, generally in the shape of an ankh. Its small metal disks, like those on a tambourine, produce a rattle when shaken that sounds like wind moving through papyrus reeds. The sistrum may have originated with the practice of shaking bundles of papyrus stalks.

Taueret - A netert whose name means "Great One," generally portrayed as a pregnant hippopotamus with the legs of a lion and the tail of a crocodile. She was thought to assist in the daily birth of the sun, the rebirth of the deceased into the heavens, and was also regarded the protectress of women and childbirth.

tcheref - A sacred dance performed during funerary rites in which two dancers' bodies imitated the position of the sign for gold. This rite enabled the deceased to remain imperishable and radiate Divine Eternal Light.

Tefnut - The netert of moisture and wife to Shu, air. Tefnut is generally portrayed as a lioness.

Thoth - The neter of wisdom said to be self-begotten, first appearing on a lotus flower through the power of utterance, or the Divine Word. He was also purported to be the heart and tongue of Ra or Divine Intelligence. Thoth is accredited with inventing language and writing, the sciences and arts, medicine, magic, mathematics, astronomy, astrology, and all known and unknown knowledge. Thoth was also referred to as the "Measurer of Time" and the "Keeper and Recorder of all Knowledge." In his role as scribe, Thoth recorded the results of the final judgment of the deceased or initiate during the Weighing of the Heart ritual in the Double Hall of Ma'at. He is usually portrayed as an ibis-headed scribe with palette and reed pen in hand.

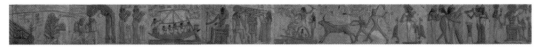

tiet - see Belt of Isis.

Tutankhamon - Pharaoh of the Eighteenth Dynasty from 1343 to 1325 B.C. who restored the Amon priesthood following the demise of the heretic pharaoh, Akhenaton, who tried to enforce the unpopular worship of one deity, Aton. His nearly intact tomb was discovered in 1922 by the British archaeologists Howard Carver and Lord Carnavon.

uas scepter - A staff with a straight shaft, forked base and neck with the head of a strange creature with an elongated neck used solely by neteroo denoting power and dominion.

udjat - The two eyes of Ra, the right eye associated with the sun and the left eye with the moon. A number of myths refer to the eye being swallowed or damaged by the neter Set and subsequently restored, which may symbolize the waning and waxing of the moon or the setting and rising of the sun. Udjat were frequently painted on the left side of coffins serving as a window for the deceased to "see" the way into the celestial realms, and also on the bows of boats to assist in "seeing" ahead.

Upuaut - A jackal-headed neter known as the "Opener of Ways" who served as a guide to the deceased or initiate through the duat. Sometimes this role is assumed by the jackal-headed neter Anubis, the illegitimate son of Osiris and Nephthys. In addition, Upuaut is the name of the small robot that was utilized by Rudolph Gantenbrink's exploration of the Great Pyramid's airshaft in 1992 to 1993.

uraeus - An upraised cobra worn on the diadem of the pharaoh signifying the yogic mastery and enlightened awareness of the king that also served to "spit in the eyes" of the king's enemies.

Wadjet - A netert generally depicted as a woman or cobra wearing the red crown of Lower Egypt or sometimes the double crown which united Lower and Upper Egypt. Her counterpart is the vulture Nekhebet who symbolized Upper Egypt.

Weighing of the Heart - A ceremony performed in the Double Hall of Truth in which the heart of the deceased or the initiate is weighed on the Scales of Justice against a feather. If the heart weighed heavy, the impurities of the heart were devoured by a monstrous creature named Ammit.

wesekh - A jeweled or beaded broad-collared necklace.

yin - The passive, feminine force of nature that is intrinsically linked to its opposite, yang.

yang - The active, masculine force of nature that is intrinsically linked to its opposite, yin.

ABOUT THE AUTHOR

Melissa Applegate is a popular public speaker on Egyptian and Tibetan mysticism; a facilitator of workshops and a private tutor in the areas of meditation, mudra and mantra, shamanic dream realities, and the use of quartz crystals as information storage and retrieval devices. She periodically leads group pilgrimages to sacred sites worldwide for purposes of initiation and information retrieval. She is an intuitive counselor skilled in the use of tarot and clairvoyance. Melissa is a longtime student of Tibetan Buddhism, having received the Avalokiteshavara and Kalachakra initiations from His Holiness, the Dalai Lama, as well as other empowerments from esteemed Tibetan lamas. Additionally, she is a contributing author to the book *Phenomenal Women: That's Us!* by Madeleine Singer. She presently lives in Palm Springs, Florida, where she enjoys hobbies of gardening, computing and joyful living!

The Reading Etc. Limited Edition Collection

Each illustration in this book has been reproduced from commissioned friezes displayed and available from Reading Etc. retail stores.

In the tradition of Ancient Egypt, Reading Etc. is making available a Limited Edition of these hand-created friezes, to perfectly adorn your home or office with beauty and blessings that transcend civilization and history.

Each frieze is hand crafted and carved from a mixture of special resins, molded individually, and then hand-painted by a single artisan to create a unique work of art, unlike any other. Telling a unique story that speaks of the spiritual essence of ancient Egyptian life, myth and wonder, each panel is lightweight and can be easily mounted on the walls of your home or office.

The symbolism inherent in each frieze is hand-scribed on an elegant Numbered and Signed Certificate of Authenticity.

To purchase your own limited edition frieze or request a free catalog visit readingetc.com or call toll free 1.877.909.7323

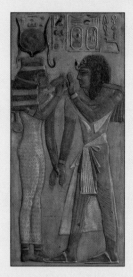

Hathor Offering Menit Necklace to Seti I
This necklace, though still a mystery, is associated with love, birth, renewel, fertility and potency and it is believed that the essence of Goddess-Hathor was transmitted as it was exchanged. The panel represents love and harmony between a couple as well as generosity, sensuality, fertility, and potency.
Dimensions: 42"H x 7½"W x 1"D #011050405

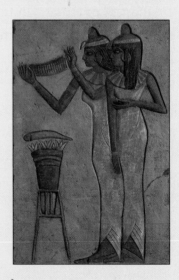

Festival
Music played a large part in the lives of ancient Egyptians, not only as a means of entertainment but also as a tool for health and healing. This panel may be beneficial for those interested in developing artistic ability, especially in the areas of music, dance and the performing arts, and creating a relaxed and harmonious environment.
Dimensions: 42"H x 29"W x 1"D #011050302